Compañeras

COMPAÑERAS

Women, Art, & Social Change in Latin America

BETTY LA DUKE

City Lights Books
San Francisco

Third Printing: January 1991

Cover: *Literacy Campaign* by Cecilia Rojas (Nicaragua)

Design: Kim McCloud and Nancy J. Peters
Typography: John McBride and turnaround

Articles on women artists of Latin America by Betty LaDuke have appeared in the following publications: *Américas, Art and Artists, Arts and Activities, Calyx, Cimarron, Community Murals, Feminist Studies, Kalliope, KSOR Guide to the Arts, Latin American Perspectives, Massachusetts Review, MS Magazine, Nicaraguan Perspectives, Northwest Review, Off Our Backs, San Jose Studies, Women–A Journal of Liberation, Women Artists News, Women's Art Journal, Women's Press.*

Photo Credits: Figures 6 and 9 photographed by Ross Sutherland; Figures 12 and 13 photographs courtesy of Museu du Indio, Rio de Janeiro, Brazil; Figure 22 collection, Nicaraguan Ministry of Culture; Figure 31 photograph by Margaret Randall; Figure 52 photograph by Peter Westigard; Figure 59 photograph by Irma Leticia Oyuela; Figures 102-106 photographs courtesy of Margarita Fernández; Figure 136 photograph by Maria Adair; Figures 146-148 photographs courtesy of Sonia Castro.

Library of Congress Cataloging-in-Publication Data

LaDuke, Betty.
 Compañeras: women, art, and social change in Latin America.

 Bibliography: p.
 1. Art and society—Latin America. 2. Feminism and art—Latin America.
 3. Women artists—Latin America. I. Title.
N72.S6L3 1985 704'.042'098 85-17513
ISBN 0-87286-173-2
ISBN 0-87286-172-4 (pbk)

City Lights Books are available to bookstores through our primary distributor: Subterranean Company. P. O. Box 168, 265 S. 5th St., Monroe, OR 97456. 1-503-847-5274. Toll-free orders 1-800-274-7826. FAX 503-847-6018. Our books are also available through library jobbers and regional distributors. For personal orders and catalogs, please write to City Lights Books, 261 Columbus Avenue, San Francisco CA 94133.

CITY LIGHTS BOOKS are edited by Lawrence Ferlinghetti and Nancy J. Peters and published at the City Lights Bookstore, 261 Columbus Avenue, San Francisco, CA 94133.

To Chela
compañera and friend

ACKNOWLEDGEMENTS

Stimulation for the four years of travel, research and writing that led to the stories that compose *Compañeras: Women, Art and Social Change in Latin America* began with: Winona LaDuke, my daughter, who presented me with my first Chilean *arpillera,* purchased from Nelly Link at the Eugene, Oregon Center for Human Rights in Latin America; and Jim and Martha Doerter, who brought me an unusual gift, birthing dolls from Peru.

This book would not have been possible without the many compañeras—those talented artists and artisans of the fourteen countries I visited—who generously shared with me many aspects of their personal, political, and creative experiences and aspirations.

After hearing about my first, 1981, ventures in Chile, Peru, the San Blas Islands, and Nicaragua, my friends Gerri and Len Pearlin and the writers Margaret Randall and Fernando Alegría encouraged me to begin to write and then to continue my travel and research. Support came, too, from Cynthia Navaretta, editor of *Women Artists News,* who published many of my early articles on Third World women artists.

In Oregon I received support from the faculty and administration of Southern Oregon State College through Carpenter grants in 1983 and 1984 and an Instructional Improvement grant in 1984, from the Oregon Committee for the Humanities with a 1982 grant awarded for travel and research in Nicaragua; and from Gina Ing, editor of *KSOR Guide to the Arts,* a monthly magazine published in conjunction with Ashland's public broadcasting station, who first published my articles. In innumerable ways I have relied on the support of my long-time Ashland friend Chela who patiently encouraged the verbal expression of my visual journeys. Many thanks also to Lois Wright, who could read my handwriting and type it all, many times over.

Other friends such as Fred Clayton were helpful, for they passionately insisted that I visit Haiti; and while there, Stan Spritzer helped me to meet the women painters. Thanks to Samuela Lewis, editor of *Black Arts: An International Quarterly,* who suggested that I visit Brazil; to Luiza Marquez, assistant to the director of the Museum of Modern Art in Salvador, Bahia, Brazil, who helped make it possible for me to interview artists who, fortunately, were bilingual; and then served as translator when I interviewed the lacemaker, Ester Almeida Dos Santos.

Special thanks to Peter Westigard, my husband, who has always been supportive of my travels and creative work, both as an artist and as a writer.

I am extremely grateful to the City Lights publishing team, and especially Nancy J. Peters, Kim McCloud, Bob Sharrard, Myia Kerr and Lawrence Ferlinghetti, who shared with me my enthusiasm for giving greater visibility to the lives and creative endeavors of the women of Latin America. Throughout this book production process, I have really enjoyed working with another special compañera, my editor, Nancy J. Peters.

CONTENTS

INTRODUCTION

A birthing doll from Peru, an image of political repression embroidered on a Chilean *arpillera*, and a brilliantly-colored *mola* from the San Blas Islands: these three art works, given to me as gifts, sent me on a treasure hunt through fourteen Latin American countries, where rural and urban women are dramatically reshaping traditional crafts and fine arts media in a time of unprecedented change.

Of the three years I lived in Mexico, I spent one of them, 1956, in a small Otomi Indian town, where I worked as a mural painter and taught English. I was to gain there not only an intense awareness of the cycle of birth and death, but came to admire how the lives and work of the community's artists—the women weavers—were closely related to the environment within the context of a long cultural heritage. When I returned to the Valle de Mesquital after an absence of twenty-two years, I was startled by the enormous changes that had taken place. What I learned on this visit about the effects of economic and social dislocations gave me a perspective from which to assess the impact of both negative and positive developments in Third World women's arts and crafts.

As I developed a curriculum for my Women and Art class at Southern Oregon State College, I was limited by the available literature and slides, which focused primarily on women's art from the United States and Europe. Because my students found relevance and excitement in that part of my course that dealt with our own country's artists of Native, Latina, African, and Asian descent, I was encouraged to search out and add examples of women's art from Latin America, Asia and the Pacific. This was the beginning of *Compañeras*, together with articles I began publishing in various art and women's journals. I am neither anthropologist nor art historian, but rather a working artist and teacher; and my purpose in bringing this book together is to acquaint the reader with a representative selection of women artists I met in Latin America, and with whom I felt a special affinity. They come from every class, many ethnic origins, from Mexico in the North to Brazil in the South, and from countries as politically far apart as Haiti and Cuba. They are agricultural workers and small shopkeepers, mothers and college professors. With each woman I interviewed a bond of mutual respect evolved as we discussed our common interests as women and artists concerned with feminist and social issues.

I have called this book *Compañeras,* which means companions or comrades; this is how I felt about the women included

in it. I first heard this word as a popular substitute for the conventional Señorita or Señora in Nicaragua, where it suggests a condition of equality, one accorded women after their participation—often in active combat—in the overthrow of the corrupt Somoza regime. I felt entrusted with a special responsibility in Pinochet's Chile when the embroiderers of *arpilleras* whose husbands and children are among the "disappeared" said to me as I left: "Please don't forget us!"

STRETCHING THE BOUNDARIES: FIBER & FABRIC

Displacements caused by migrations from rural to urban areas, industrial development, foreign aid and Peace Corps activities, and especially the immense growth of tourism are some of the factors that have promoted the adoption of mass market techniques in ancient crafts. At the same time, the avid interest of tourists, whose own plasticized societies have deprived them of meaningful and beautifully-made textiles and handcrafts has encouraged women from primal cultures to pass on their knowledge and skills to the younger generation.

Frequently the adaptation of traditional crafts to new needs can assure the survival of the craft itself. Intricately designed bags that once held coca leaves or tortillas, have been modified to accommodate school books and the various objects carried by tourists. Cloth and clay birthing dolls made by Peruvian and Amazonian Indians have found new outside markets, too; yet their original use remains intact—as educational toys that carry the meaning of life's continuance.

Sometimes innovation can be striking. I have been surprised sometimes by how one woman can make something entirely new out of an everyday act by simply saying, "Why not?" and then following her creative instinct, as Margarita Reza of Ecuador did when she developed bread dough into an art form.

The persistence of some art and craft traditions can be said to stem from positive acts of defiance against pressures to join mainstream society. In spite of massive outsides influences, Cuna Indian women create their *molas* just as they always have. *Huipiles* are still made and worn by Guatemalan women, even though the bright colors of these garments have provided easy targets for government planes intent on destroying villages suspected of harboring revolutionists.

In recent years, the innovative use of burlap and fabric scraps by Chilean and Grenadan women provide examples of how art is related to the growth of political consciousness. Chilean *arpilleras*, with their critical images, are not, needless to say, government approved, and can only be seen or purchased through the Catholic Church's Vicaría de Solidaridad. When I visited Grenada in 1983, rural women were being encouraged by Grencraft to express through such crafts as appliqué and straw weavings, a new independence, self-sufficiency, and pride in their Indian and black African heritage.

I interviewed a great many painters over the last six years, most of whom divide their time between studio work, regular jobs—often teaching—and household and child care responsibilities. Some of them have been trained in universities or professional art schools; others have had no formal training at all. Their styles are numerous, ranging from realist to abstract expressionist; and most of them have in common a strong emphasis on the figure.

I am most attracted to artists who probe beneath polite surface facades of their societies and to those whose vision centers on their identity as women. The themes based on women's common experiences explored by these artists have a universal appeal: sexuality, motherhood, gender, and aging.

The canvases of Brazilian painter, Maria Adair, are charged with erotic vitality and a joyous sensuality. Rosemarie Deruisseau, Mariléne Villedrouin and Louisiane Saint Fleurant, although very different in styles and technique, have drawn on Haitian Voodoo spiritual tradition which gives importance to female powers and a powerful role to women themselves. Margarita Fernández of Puerto Rico uses the family photo album as a matrix for her drawings which reveal the childlike role expected of women in upper class society. Cuban painter Antonia Eiriz, who worked as a seamstress, gives us a dark vision of an anguished Virgin Mary sitting at her sewing machine receiving the news of her pregnancy; while Lesbia Vent, another Cuban painter, satirizes society's condemnation of older women.

The work of some painters reflects a heightened moral awareness and sense of community. Nicaraguan muralists Hilda Vogl and Julia Aguirre who work in the tradition of primitive landscape now add such postrevolutionary details to their paintings as tiny signs urging literacy. Fanny Rabel, the renowned Mexican artist, has used the graphic poster form to publicize political repression in Guatemala. Some Solentiname landscapists and Haiti's primitive painter Saint Fleurant present a visionary dream of a beautiful world at peace.

Perceptive observers of a social world which must be the future home of their children—or visionaries who give us imaginary projections which reflect our deepest aspirations and desires—these women artists strengthen an individual and collective image of woman.

GAINING VISIBILITY

Cooperatives, churches, unions, and workshops are some of the new organizations helping to increase the visibility of Latin American women artists. Many primal peoples have begun forming cooperatives which enable them to take control of marketing procedures as well as their earnings. Support

groups from the liberal wing of the Catholic Church or private individual efforts, such as those of Kiki and Gabriel Suárez's *Galería* in Mexico, aid in international distribution of art work and disseminate information on current political events. International solidarity groups also help; Oxfam, American Friends Service, various state human rights committees, CARUGA, Relief Committee for Guatemala Refugees.

In Brazil, Mexico, and Puerto Rico, professional women artists are more frequently joining college and university faculties; at the Mexico City National Fine Arts School a new course on Women and Art is underway. As these women gain stature, they are enabled to participate more fully in graphic workshops, galleries, and museum exhibitions. Much of this is due to their professional preparation which in many cases did not come easily, but once achieved, prepared them to be assertive, challenge the status quo, and earn the recognition they merit.

Networking on all levels has become an important means of learning and sharing. Though the means vary, the end result is breaking down the barriers of women's isolation. In both Mexico and Puerto Rico, artists have formed feminist art groups. In the United States, women's caucuses of the College Art Association and the National Art Education Association are taking an interest in the concerns of non-white women artists at home and of women artists in Latin America, Africa and Asia. Feminist publications such as *Calyx, Women Artists' News, Kalliope,* and the *Women's Art Journal* are more frequently presenting examples of Third World Women's Art. International exhibits of women's art are more difficult to arrange, but are making strong beginnings; and the publication of popular posters has been still another means for women to make public their ideas and political commitment.

COMPAÑERAS

This book tells the stories of remarkable women—artists, teachers, catalysts, and friends—whose personal examples have helped inspire others. For all Latin America's diversity, there are things the arts hold in common that are valid regardless of time, place, or cultural singularity. Traditions are never static. One woman's pursuit of a creative vision can make a difference for her own life as well as for her community's. Sharing our experiences becomes a means of narrowing the divisions between individuals and nations as it broadens our own personal sources of inspiration. Art is not isolated from life, or from the process of social change. These Latin American women's concerns and artistic achievements deserve to become a visible and viable part of our world heritage. There is much to be learned from them, not only from their art but also from their courage.

Betty LaDuke

Compañeras

Embroideries of Life and Death
Chile

Two very different groups of embroiderers in Chile have in recent years received international recognition, but until recently these women were not artists. Now, this folk craft has become for them a means of earning an income to support families, and more: through it they are bringing a message to the world and, in the process, reshaping their lives. Although brightly colored threads outline the surface designs made by these women, the images they create differ enormously. The embroiderers from rural Isla Negra [*fig. 1*], organized in 1969 by a philanthropic patroness, are encouraged to turn to folklore and uncontroversial scenes of daily life in the past for themes, while urban embroiderers in Santiago, many of them victims of brutal political repression, use their craft to make a strong political statement.

June 6, 1974: Dina Loagos' husband was employed for seventeen years as a mechanic in a metal factory and was active in the trade union. The youngest of their seven children was two years old when Dina's husband was surrounded on the street by six plainclothesmen and pushed into a car, never to be seen nor heard from again.

May 21, 1975: A knock on the door at 2:00 a.m., and Victoria Diaz Carro's father, head of the Graphic Workers Union, was taken by twenty-five militiamen to the torture chambers of Grimalde Prison. He, too, was never heard from again.

September 10, 1973: Estele Hidalgos' husband, director of the construction workers' union, disappeared. March 4, 1975: When Estele's only son, a university student, disappeared, she had to move in with her sister and her children.

The *desaparecidos*, those who disappeared, were never charged with a crime, brought to trial, or seen again. They are among the many Chileans who have spoken up or organized others to protest exploitative working conditions, lack of free speech or the imprisonment of workers, family and friends.

Dina, Victoria, Estele, and many other women began to create their *arpilleras* or "embroideries of life and death" in 1975, approximately two years after the coup and assassination of President Allende. Most of them had been housewives without any particular craft skills until they became victims of the Pinochet dictatorship. In the words of one woman, "their hands were forced to develop or move in new ways to provide a means of sustenance for themselves and their children. Necessity and imagination formed the basis for creating *arpilleras,* which not only provide food but a means of visually expressing the reasons for their situation."

The dictionary meaning of *arpillera* is "sackcloth or burlap." On a twelve by eighteen inch piece of burlap, colorful fabric scraps are cut into shapes and arranged to tell a story. The finished *arpillera* is then framed by a bright wool crocheted border. There are three techniques of construction: the *flat or planar method,* in which fabric shapes are stitched to the burlap along the outer edges of the forms; the *raised or relief techniques,* in which doll-like figures are partially raised from

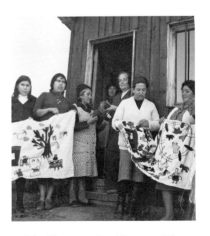

1. Isla Negra embroiderers with Leonora Soberina de Vera (1981).

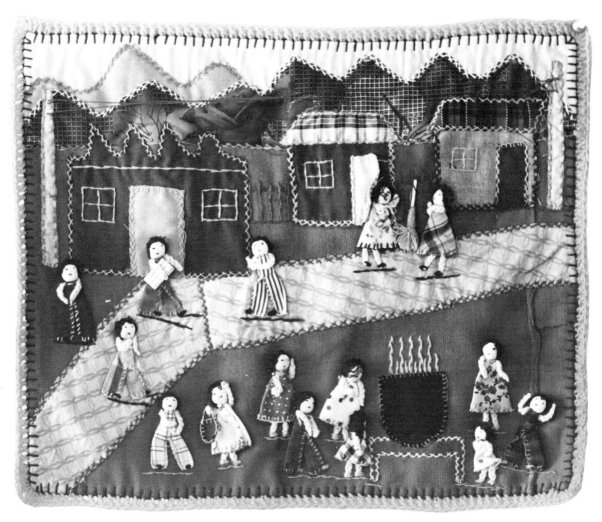

2. Dina Loagos, *Sharing a Common Pot of Food* (1981). *Arpillera,* relief technique.

the surface; and the most recently developed glue technique, in which the fabric shapes are glued to the surface and then outlined with several thicknesses of glued contrasting wool.

The embroidery of cloth with traditional decorative flower motifs had long been a popular folk craft of Chilean women. These embroideries often used to cover cakes or sweets, were given as gifts to commemorate special occasions. Presented to a foreign visitor, an embroidery was meant to capture a special memory of Chile.

Over half of Santiago's population of four million live in shanty communities in houses constructed from sheets of corrugated metal, cardboard, flattened tin cans, plastic, and tarp, which are easily penetrated by the wind, rain, and cold of the Andean winter. Many homes lack basic sanitary facilities, electricity or water; and their residents are unemployed or marginally employed, malnourished, and in need of medical attention. These conditions are shown in Dina Loagos' *arpillera* [*fig. 2*]. Box-like homes are lined up in a row, "robbing" the

electricity from the major utility poles. The man in front of the factory holds a paper which tells him that the factory is closed and that he is now unemployed. The people below are all families of unemployed workers who are cooking together and will share a common *olla* or pot of food.

Every woman in Dina's *arpillera* workshop now heads a household, their husbands and sons are among the *desaparecidos*. Amnesty International confirms that thirty thousand people have disappeared into the Pinochet regime's prisons, torture chambers, and unmarked graves. The numbers still continue to grow; and they represent teachers, doctors, lawyers, priests and nuns, as well as laborers. Each day new lists are posted with the names, professions, and dates of disappearance. Moreover, a million people, or one-tenth of the Chilean population, have had to go into exile.

The families of these victims began to turn to the Catholic Church for help; in 1973 the Vicariate of Solidarity was formed. The *vicaría* is concerned with human rights and it provides lawyers to defend people who are detained and tortured. Additionally, it promotes the right to work, health, and basic human rights. Among its assistance programs, the *vicaría* has initiated community industries and *talleres*, artisan workshops, in which embroidered clothing and small craft products are made. By 1975 there were ten such *talleres*, each with twenty women, producing *arpilleras*. The women meet once a week, learning new skills from one another as they develop confidence and a new sense of pride. They no longer feel isolated and have become articulate about their personal and political situation. Ironically, the repression has made them stronger.

Frequently, a common theme is selected by the group, then an *arpillera* is designed and executed by each woman, and on occasion all of the *arpilleras* with a similar theme are sewn together to form a large mural, like those that decorate the walls of the *vicaria*. *Arpilleras* are unsigned or anonymous, although sometimes a little pocket, sewn onto the back, contains a folded paper with the maker's name and a written explanation of the *arpillera's* meaning. Quality is maintained in each *taller* through critical discussion on technique, design, and theme. Each woman is permitted to make only one *arpillera* per week, or two in case of extreme economic need. She receives full payment, except for ten percent which is kept as a common group emergency fund. The embroideries are carried to the United States, Germany, France, Holland, and Switzerland by organizations such as Oxfam, where they are sold in solidarity or peace centers. The night before I left Chile, I was told that the wife of the American Friends Service Committee had been apprehended at the Santiago airport, her luggage containing many *arpilleras*. She was taken to the police station, blindfolded and questioned through the night before being released. The *arpilleras* were confiscated.

Lonquen is the name of an *arpillera* by Victoria Diaz Carro [*fig. 3*]. In 1978 the bodies of fourteen *desaparecidos* were found in a furnace at Lonquen, an isolated rural area with abandoned calcium mines. Among them were five men from a nearby agricultural community who disappeared in 1973; they were candidates for office from the Movimiento de Acción Popular Independencia. The memorial service for them was attended by 1500 people who proclaimed their desire for respect and tolerance for diverse ideas. A Pablo Neruda poem appropriate to the Lonquen massacre is embroidered on this *arpillera*. "Even if a million footsteps pass over this site for a thousand years, they will not erase the blood of those who fell here. Even if a million voices pass over this silence, the hour that you fell will never be forgotten."

Estele Hidalgo, a professional nutritionist at the University of Santiago, was blacklisted from her profession after the disappearance of her husband and son. Twenty-five members of her family have been exiled. Her *arpillera*, called *Cesante (Unemployed)* [*fig. 4*], contrasts a wealthy man gorging himself while the unemployed have no food, water, or electricity. She often visits Santiago's Human Rights Commission, a meeting place for thousands like her who congregate there in the evenings to share news of the exiled and of new victims of the Pinochet government.

3. Victoria Diaz Carro, *Lonquen* (1981). Arpillera, planar method.

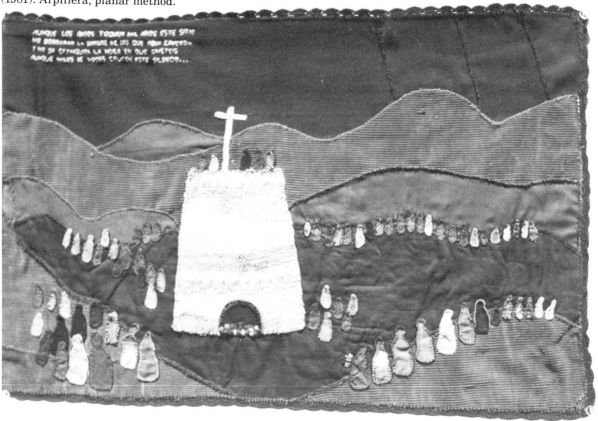

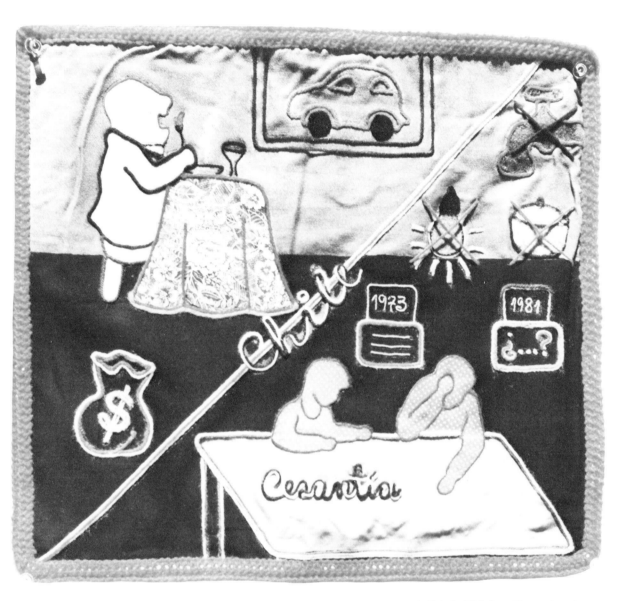

4. Estele Hidalgo, *Unemployed* (1981). *Arpillera*, glue technique.

Another group of folk artists has also had an impact on Chilean art and culture: the Isla Negra embroiderers [*fig. 5*]. In fact, when the women of Santiago first began their embroidery workshops, they viewed the work of the Isla Negra women as a kind of model; however, after experimentation they decided that the wool embroidery technique used there was too slow and costly for their purposes.

Isla Negra is a small town located on the Pacific coast two hours by bus from Santiago; the women there are famous for their *bordados,* embroideries which became world renowned after they were carried to Europe by Chile's poets Neruda and Violetta Parra.

The development of this craft began through efforts of Sra. Leonora Soberino de Vera, who worked first with nutritional projects and then began to encourage women to embroider. She

5. Isla Negra embroiderer (1981). *Bordado*, embroidery.

says, "I encourage only folk themes, and themes from the past, such as the potato harvest, a horse corral, fishing, village and home life. I made contact with a museum director through a friend. We had our first exhibit of Isla Negra embroideries at the Santiago Art Museum in October, 1969; thirty embroideries were shown by seventeen women. Everything sold in the first half hour. The women said, 'this is money from heaven.' Pablo Neruda saw the embroideries and loved them. He promoted them all over the world. Every year we make an exhibition. There are not enough for the demand."

I was told that the women make between two and six embroideries a year and that the price for each is $100 or more. In the embroidery technique Isla Negra women use, the entire surface, the form of each tree, leaf, bird, or person is completely filled in by using a stitch which crosses back and forth over the object, on the back as well as front surface. This technique gives the embroidery the weight and texture of a weaving.

The women meet with Leonora every other week, in a little house they have constructed themselves for storing wool and other supplies. Leonora brings the wool with her from Santiago and it is sold to the women at cost; then she sees their work in progress, their "embroideries of life," and continues to encourage them. These women of Isla Negra do not face the fear of repression as those in the *arpillera* workshops do; they meet openly to sew. Recipients of official prestige, they exhibit their work annually in museums and galleries.

Leonora Soberina de Vera has now begun to delegate some of her administrative authority to the others, who have formed their own organizational structure with a president, secretary and treasurer. They are learning how to purchase supplies, make and maintain museum and gallery contacts.

Though economic necessity has been the common catalyst in the development of both the *arpilleras* and the Isla Negra embroideries, each expresses a different view of Chilean reality. The women of Isla Negra have been primarily directed by the vision of a kind, generous patron to develop embroideries that reflect the quiet idealism of rural life. The private deprivations experienced by families through seasonal unemployment, high alcoholism, lack of proper nutrition, etc., are not the realities they are encouraged to express. Also, this small rural community has not suffered from direct political repression, with friends and family exiled or "disappeared." And so these decorative, colorful Isla Negra embroideries offer artist and viewer alike a bucolic, joyous vision of nature and life.

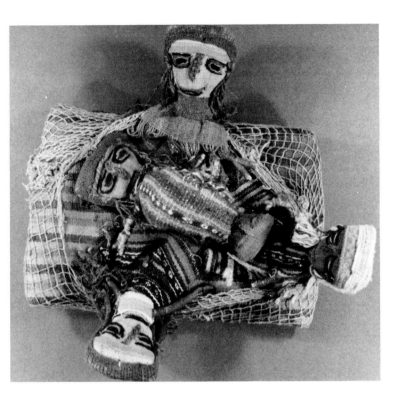

6. Birthing dolls arranged in the form of a cross.

Birthing Dolls
Peru and Brazil

My interest in birthing dolls began with a gift, a group of dolls in the form of a cross, on a flat cloth-covered mat [*fig. 6*]. The mother, with her huge belly, is in the center; the small head of the baby protrudes from the womb. The midwife is there to receive the child; the horizontal arm of the cross is formed by her assistants. All are constructed from dried banana leaves, with small twigs wound with twine for hands. Just a few inches in size, they are dressed in scraps of coarsely woven old fabric in Inca patterns, in muted earth tones.

Though the fabric is torn and rotted with age, the dolls are newly made and sold by vendors in Lima, capital of Peru. I wandered from vendor to vendor, ignoring the embroidered blouses, hand-woven rugs, brass carvings and tourist trinkets, searching for the dolls. At first each group seemed similar, but soon I noticed many variations. The hands of some midwives were literally clutching the child, as if snatching it from a reluctant womb; in other groups, the midwife awaits the baby's arrival passively. Sometimes the mother appears wild-eyed, with bared teeth outlined in bright red stitches expressing the agony of birth. This public exposure of a private experience, the intense expressions of the group—mother, baby, midwife and assistants—in a primal life event, allow little comparison with the pink plastic baby dolls of our culture.

"Who makes these dolls? Where do they come from?" I asked. Most come from Chancay, some from Cuzco, I learned, but "we don't know who makes them. Once a month some señoras come to Lima to sell them. We don't know their names or where they

7. María Lipu de Morveli, Cuzco, Peru, (1981).

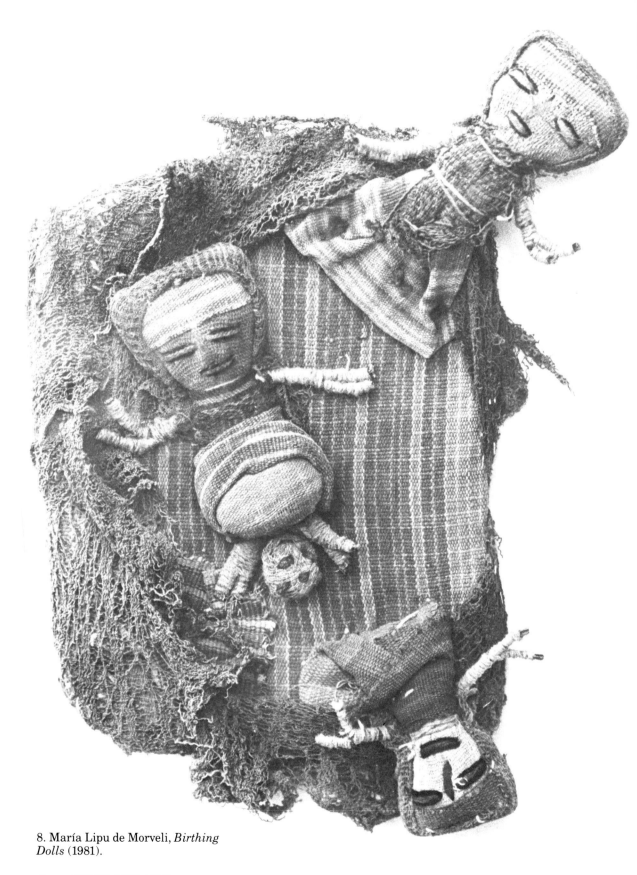

8. María Lipu de Morveli, *Birthing Dolls* (1981).

live. They have been making the dolls for a long time, maybe ten years, and the tourists buy them for souvenirs."

I left for Cuzco in hopes of finding the dolls and dollmakers. My first stop was at María Lipu de Morveli's stall in Cuzco's Artisan Center which was crowded with the many items that she, her sister, their husbands and children make for the tourist trade [*fig. 7*]. Among many styles of dolls were birthing dolls.

As it happened, María, an educated, articulate woman, was willing to explain their meaning to me. The configurations of her birthing dolls were not symmetrical [*fig. 8*]. There was only the midwife to receive the child, with one assistant to attend the mother. A blue net covered and almost smothered the group. María said the net protects the women from the cold Andean winds and gives privacy, since women give birth in the same hut where the family lives. The placenta is burned or buried. For three days after giving birth the mother is not permitted to eat potatoes, onions or garlic, or to salt her food.

The dolls were originally created during the Inca period and wore typical costumes of the era. They were made as toys for children, but were also intended to be educational, a truthful model of life. Now, poor women make the dolls to sell. María said she uses old fabrics found in tombs, sold to her by people who rob them. She showed me other kinds of dolls as well. These included *Matrimony of Poor People* [*fig. 9*], a father and mother carrying a baby, the style of clothes and simple head-dress classifying them as "poor" (not of Inca nobility); *Three Children* [*fig. 10*], small figures carrying long strands of wool that symbolize women's traditional work as weavers; and *Woman in a State of Agony* [*fig. 11*], with red lines of stitching to form her open mouth and teeth.

When I returned to Lima, the vendors and their merchandise were gone, probably chased away by police, who try to discourage these stalls. I then went to the museums, searching for dolls. The private Amano Museum had several dolls arranged to portray such domestic scenes as women weaving, and there was also a partial house, like an open doll house, which contained a family mourning a dead person. Again, these dolls had been made not only to entertain children, but to address basic facts of life, to mark rites of passage. The large ancient dolls were well preserved, their clothing cleaner and brighter than the recently made dolls composed of ancient scraps robbed from the tombs. No photographs were permitted, dolls are not depicted on picture postcards, and no information on them was available. There were no birthing dolls either; however at the Herrer Museum, in the section devoted to erotic pottery, there was one showcase devoted to *la maternidad*. These three-dimensional pottery pieces dating from the Moochila period (around 500 A.D.) depict birth scenes very similar to those presented by María Lipu de Morveli's dolls.

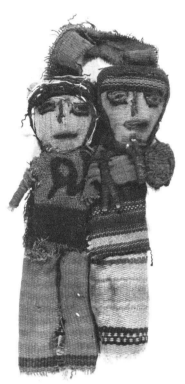

9. María Lipu de Morveli, *Matrimony of Poor People*.

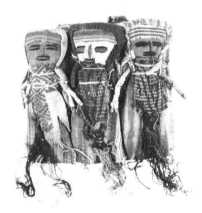

10. María Lipu de Morveli, *Three Children* (1981).

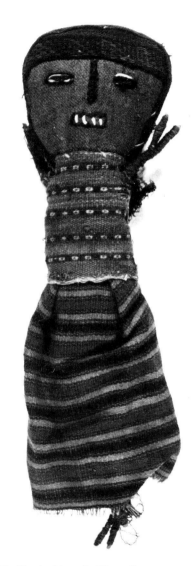

11. María Lipu de Morveli,
Woman in a State of Agony.

Exhausting the museums and their minor doll collections, I had only Chancay to visit to find the dollmakers. Chancay is some two hours north of Lima by a bus which takes one through a flat, fogged-in coastal terrain dotted with patched dwellings. Because Chancay women are known to continue the ancient dollmaking tradition as a contemporary commercial craft, I was disappointed that there wasn't a single doll in the Sunday market. But luckily, I was approached by a woman who asked, "Do you want to buy antiques?" When I explained my interest in dolls made from antique cloth, she invited me to join her, her husband, and their two young children in a taxi trip several miles north to their barrio. There, in scattered hillside homes among patches of garden, the dollmakers live—under police surveillance. To get the material to make dolls, the poor women here rob the well-preserved graves of clothes, and of antique beads and pottery as well. The contents of the graves have been proclaimed part of the national heritage, but measures taken to keep them untouched have proved ineffective. In homes here I saw shopping bags of dolls ready to supply the street vendors in Lima. The women who created these dolls seemed to know little of their historical significance, but surrounded by undernourished children with swollen bellies, nimble fingers were busy.

Three years later in Brazil, not especially looking for birthing dolls, I was surprised to find an unusual clay example in a glass-enclosed showcase at the Museu du Indio in Rio de Janeiro. These palm-sized figurines in their natural, beige clay color were embellished with facial features and body designs painted in contrasting red-brown or black clay pigment. The first doll, a singular figure approximately four inches tall, sat with legs wide spread, exposing her heavy belly in the last stages of pregnancy. A little straw apron was wrapped around her abdomen. The dark stripes circling each oblong breast, as well as her belly, further augmented the figure's full, round contours [*fig. 12*].

The second figure was part of a group consisting of the mother, a midwife and two attendants. In contrast to the Western birth position, this mother sits with her body resting on legs spread apart but folded under her. The baby's small head is seen emerging from her womb. The midwife's hands are ready to receive the child, while one attendant seated behind the mother waits with a large clay bowl, perhaps containing water for the baby's first bath [*fig. 13*]. The second attendant sits near the midwife.

The only information accompanying this intense portrayal was a card which briefly attributed the clay pieces to the Amazon Indian tribe "Karajo: Banal Island in the state of Goiás near the Araguaia River." The museum curator told me that for many centuries Amazon Indian women have shaped clay into large figures—approximately nine to twelve inches tall—that depict life situations, birth, and death. Just as in

Peru, these figures have served as instructional play dolls for children.

The future of Brazilian Indian arts is grim, however. Since 1964, the military regime has provoked a ruthless development of Brazil's interior, dispossessing Indians of their lands and annihilating whole tribes. Indians have, in some parts of the country, been considered less than human. It is like watching a reenactment of the tragic history of Native Americans in North America. Yet surprisingly, a variety of dolls, occasionally including birthing dolls, are still being produced by Karajo women, but now also for cash income. The museum curator said that clay dolls now are smaller and made more hastily to fill tourist demand which has seen a steady increase in the last few years. What is the power of the birthing image? Western art history is dominated by a baby already cleaned and calm when presented to society. Modern medicine has hidden birth in white-painted hospital rooms. Historically, however, birthing cries have crossed the thresholds of thatch huts throughout the world, heard by all, while the mother is aided and comforted by the loving hands of familar women. Children in play imitate giving birth, imitate birth pains. In some societies, men practice ritual couvade, simulating the experience of birth. The blood, fear, and awe of birth are a real and powerful experience; the birthing dolls of Peru and Brazil symbolize an aspect of life that has been lost in our culture.

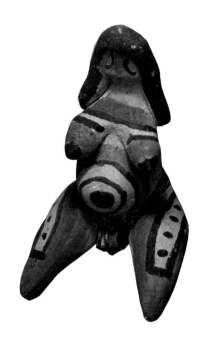

12. Artist unknown (Karajo), *Pregnant Woman.*

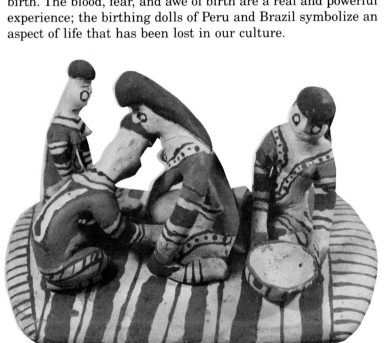

13. Artist unknown (Karajo), *Birthing Dolls.*

Changing Patterns
San Blas Islands

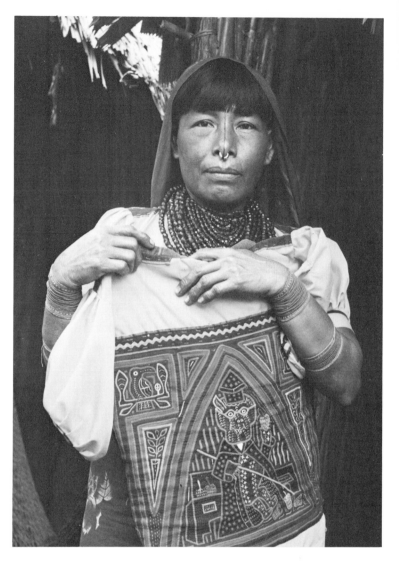

14. Cuna woman with *mola.*

Unlike many other Indian peoples of North and South America, the Cunas have been able to maintain their traditional cultural heritage with little change through the centuries. After the first devastating encounters with Spanish colonizers, the Cunas left most of their old Panamanian homelands to avoid subjugation, and isolated themselves on the nearby San Blas Islands.

The new Cuna invaders are more subtle: Panamanians, who want political control; missionaries, who seek to impart their religious beliefs; United States Peace Corps workers, who have attempted to assist the Cunas with the commercialization of *molas;* and foreign private investors, who establish hotels and tourist facilities on Cuna land for their own profit. However, the Cunas are keeping traditions and tribal organization alive by determining for themselves what new influences to accept or reject. The clothing arts of the Cuna women, the *molas* (blouses), reflect these new winds of change [*fig. 14*].

Most of the Cunas I know live on the islands of Nalunega, Coco Blanco, Isla Tuppo, Carte Sutuppo, and Mandiga Soledad which are still relatively free of outside influences. The total Cuna population of approximately 250,000 inhabit about fifty of the three hundred fifty tropical San Blas Islands. The Cunas must bring in fresh water from the nearby Panama mainland, Tierra Firma, where they maintain subsistence agricultural plots of yucca, corn, yams and wheat. In more recent years many Cuna men have been able to supplement their families' income by working in the Panama Canal Zone; the women by selling their creative work, the *molas*.

A *mola* is more than a functional garment—a blouse. It is a unique form of personal expression. The basic blouse structure is composed of two individually designed large rectangular panels, usually about eighteen by twenty-four inches, created with the same formal considerations as a painting, except that the medium is fabric. The *mola* design or image is developed from a complex blending of colors and organization of shapes and forms that can be resolved as a design or abstract pattern [*fig. 15*]. Many of the old *mola* themes were imaginative interpretations of Cuna myths: *The Tree of Life,* designed with a native palm tree, *Moon-Child Shooting Sky Dragon,* depicting the lunar eclipse, during which the dragon is kept from swallowing the moon, and *Earthmother Giving Birth to the First Snake.* These *molas* of the 1940s and 1950s have largely been bought by collectors. The dominant contemporary *mola* themes are based on bird and flower designs inspired by tropical plants and animals; some newer designs are based on current events, commercial labels, flags, and politics.

Molas evolved from an earlier tradition of Cuna body painting, the images adapted as a narrow border design for a cotton blouse surface. During the past forty years, the border design

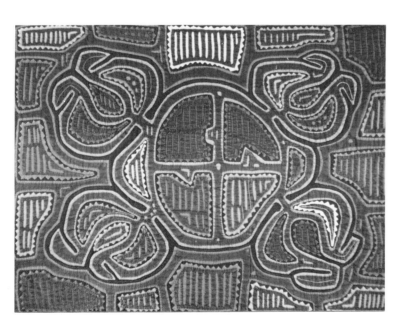

15. Artist unknown (Cuna), *mola* (1981).

has grown into two full-sized panels, making up the front and back of the blouse, which is completed by the addition of sleeves and a neck yoke. The term *mola* refers to these fabric paintings or stitcheries rather than to the whole blouse.

A *mola* maker begins by selecting her palette of colors, consisting of three or more layers of cotton fabric of the same size. She loosely stitches all the layers together around the outer edge. Usually a deep red fabric is kept for the outer surface color; one layer can also be composed of many small and patterned color patches sewn together. To create forms, sharp scissors are used for cutting through the varied layers of cloth to expose their different colors. The cut edges are then folded under and delicately stitched with matching thread to create the desired forms or shapes. The principal subjects or motifs, as well as the surrounding background areas, are cut and sewn, creating a vibrating pattern of many colors and designs throughout the entire *mola* surface. Decorative stitches in contrasting shades are also used to add texture and to embellish the surface image. Girls make their first *molas* at the age of eight or nine, using smaller pieces of fabric and less complex designs [*fig. 16*].

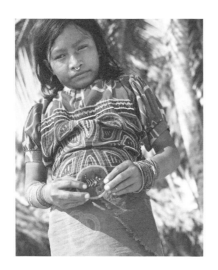

16. Cuna girl with her first *mola* (1981).

Cuna women have large collections of *molas* for their own use as blouses which they store by hanging them from the bamboo beams of their thatched huts. The women look like walking paintings. If these *molas* had been created with paint and canvas by men, instead of with fabric and thread by women, they would have found their place of recognition as a fine art form on museum walls long ago.

Women usually work on several *molas* at once, and, depending on the complexity of the design, a single *mola* can take one or more months to complete. Since the matriarchal households are large, often containing several generations of women, most household chores and child care are shared, leaving ample time for the women to dedicate themselves to *molas*.

Though some women and children accompany the men when they go to work in Panama as wage laborers, most remain home. But many signs of worldly "progress" can be seen in the bamboo thatch homes of the Cunas. During the past ten years there has been a sharp increase in tourism, which has jolted traditional Cuna life and art. Almost all of the islands now have stores containing canned and packaged foods, junk foods and all the knick-knackery of consumerism. Many men have been able to outfit their dugout canoes, the standard means of transportation, with outboard motors. Even television sets, powered by small electric generators, are seen and heard at night. These changes have affected *mola* art by providing new visual ideas which women satirically and humorously incorporate into their work.

Two examples of recent images are: *Two Men Smoking* [*fig. 17*], and *Weightlifter* [*fig. 18*]. These kinds of *molas*, actually worn by their makers, contain an infinite amount of time-con-

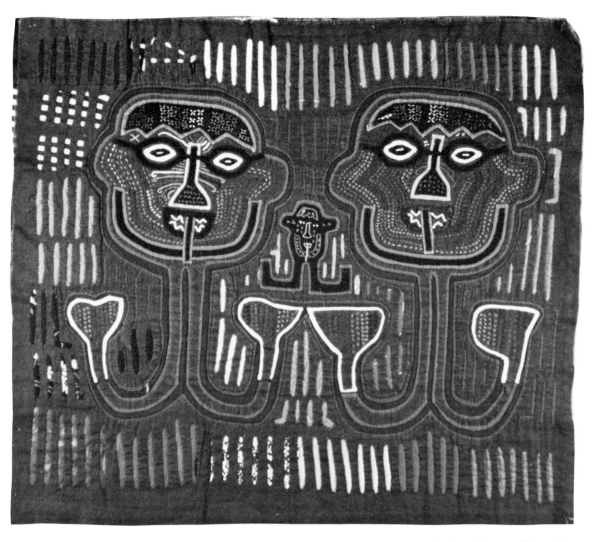

17. Artist unknown (Cuna, San Blas Islands), *Two Men Smoking, mola* (1981).

suming detail. However, many women also make miniature *molas* with simple designs for tourists [*fig. 19*].

Cuna women have paid attention to the taste in *molas* that tourists have, as well as the price met most often; and they have begun to modify some of their commercial *molas* accordingly. The sizes have changed to little patches six by eight inches, and the designs are now limited to easily recognizable, repetitious bird and flower themes; shapes are simpler with less intricate detail. These *molas* are produced in quantity and sold inexpensively to buyers who supply airport shops and import-export stores. In the 1960s, Peace Corps workers introduced the sewing machine to hasten mass production of *molas* for the commercial market; nevertheless, most women have rejected it except for attaching the blouse structure to the *mola* panel. On some of the larger islands, Cuna women have formed marketing cooperatives, transporting their work themselves to shops in Panama, and they sell directly to the larger stores.

18. Artist unknown (Cuna, San Blas Islands), *Weightlifter, mola* (1981).

However, the high standards of Cuna design and craftsmanship are still to be found in *molas* the women make for their own wear. In spite of the fact that the Cunas have had to adapt to changing circumstances, they are a proud people who know when they are being exploited. Cuna women are their own best critics, carefully distinguishing creative expression from commercial endeavors. As long as they continue to wear the *molas* they make, these artists' superb aesthetic sense and skill will continue to evolve as spectacularly as they have in the past.

19. Artist unknown (Cuna, San Blas Islands), Small tourist *mola* (1981).

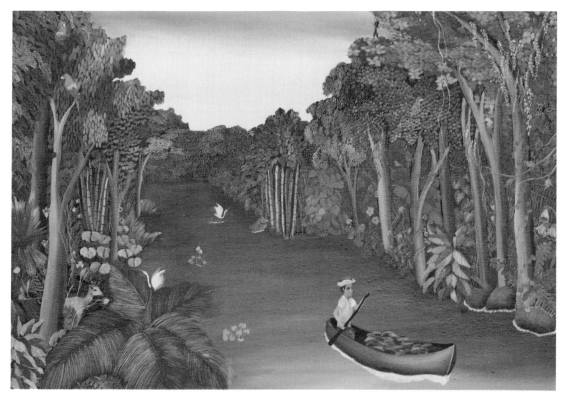

1. Miriam Guevara, *Transporting Bananas* (1982).

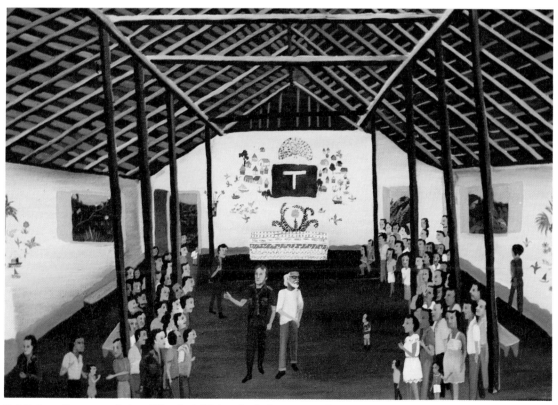

2. Miriam Guevara, *Jaime Wheelock Visits the Solentiname Community* (1980).

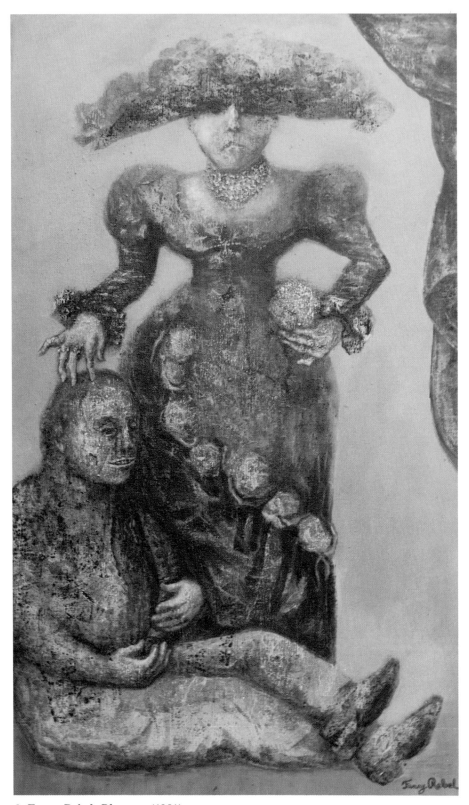

3. Fanny Rabel, *Planners* (1981).

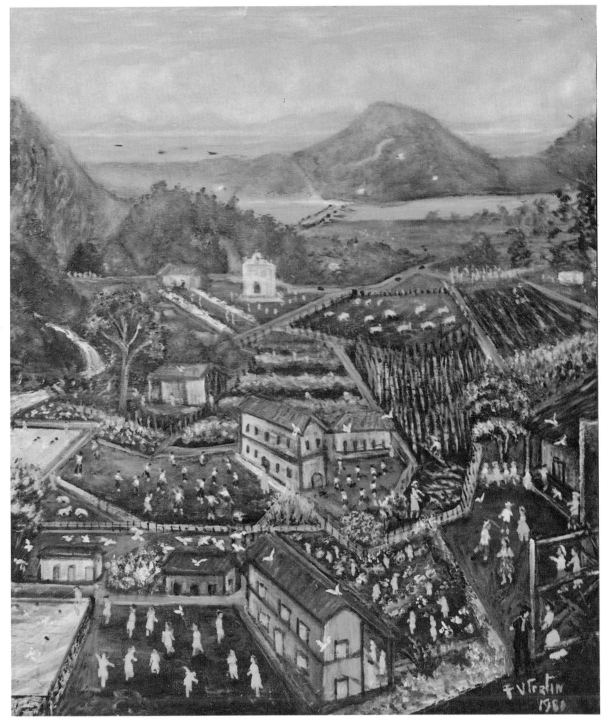

4. Teresita Fortin, *The Future, A Happy People* (1978).

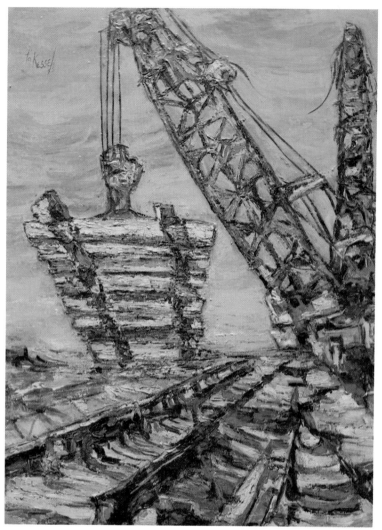

5. Juana Kessel, *Crane* (1982).

8. Julia Valdes, *Santiago Landscape #2* (1983).

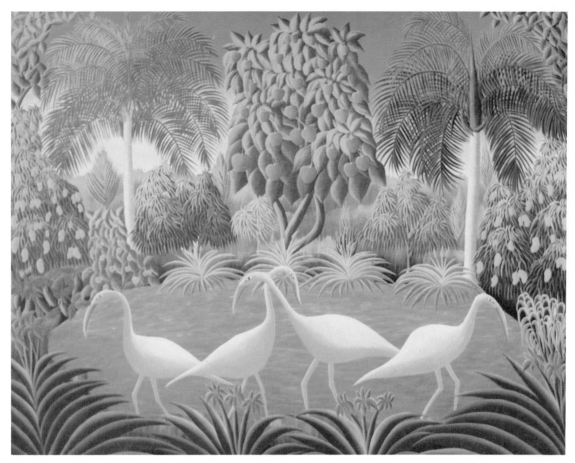

10. Vierge Pierre, *Landscape with Flamingos* (1983).

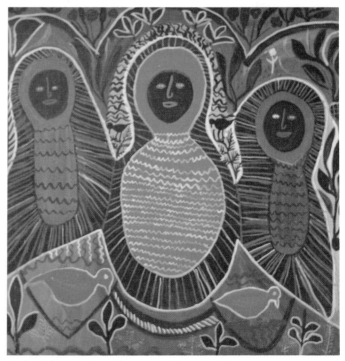

9. Louisiane Saint Fleurant, *Three Goddesses* (1983).

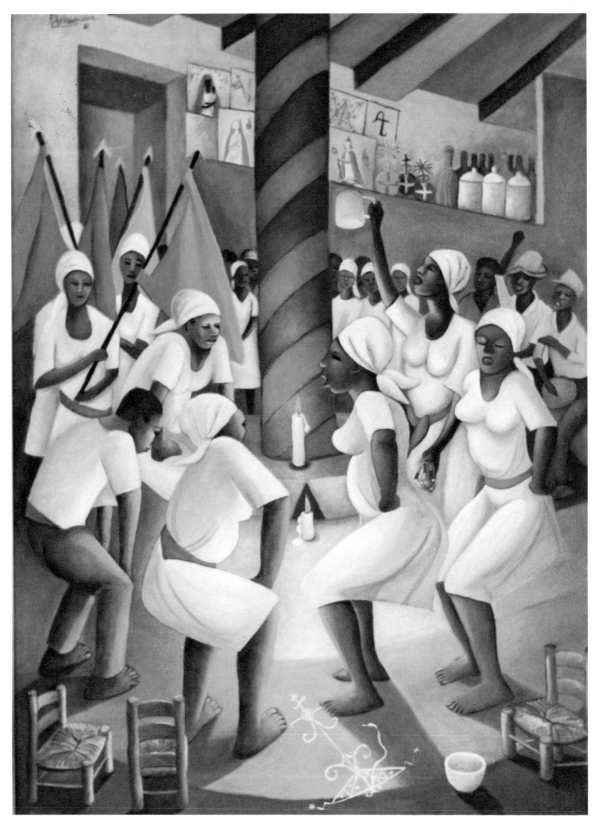

11. Rosemarie Deruisseau, *Voodoo Dance* (1980).

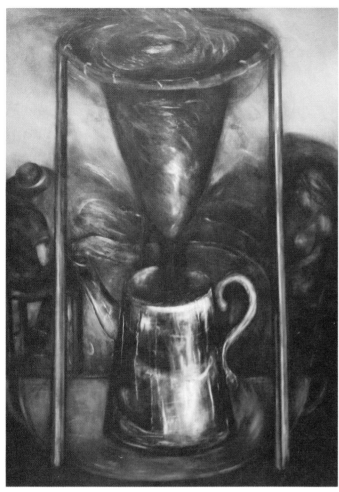

6. Flora Fong, *Ecstasy of a Coffee Maker* (1980).

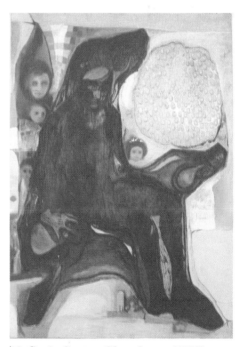

13. Sonia Castro, *Ghost Image* (1975).

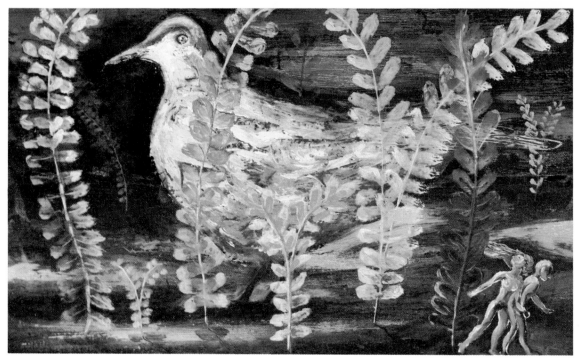

7. Nancy Franco, *Lovers and a Bird* (1983).

12. Yedamaria, *Blue Porcelain* (1983).

The Peasant Painters of Solentiname
Nicaragua

Solentiname is more than a name for a group of beautiful but isolated islands located on Lake Nicaragua near the port town of San Carlos. In recent years, Solentiname has become a symbol of people's capacity to change their lives. This is reflected in its works of art— painting, sculpture, and poetry— as well as in a cooperatively constructed Christian community, Nuestra Señora de Solentiname.

The catalyst behind this extraordinary experiment is the poet and priest Ernesto Cardenal [*fig. 20*]. In 1966, he bought some land in Solentiname, where the peasants had been living in conditions of poverty and deprivation, and with his friend William Agudelo moved there to live. During the next twelve years, a relationship was established between the two men and the people who lived there that touched all levels of their existence.

The first person to paint in Solentiname was Eduardo Arano. Cardenal speaks of having found some dried gourds used for water, with pictures carved on them by the peasant Arano. Thinking he might develop as a painter, Cardenal gave him paper and chalk. Arano and his wife Rosita made a number of pleasing drawings, and then, after the arrival in Solentiname of the young Managua painter Roger Pérez de la Rocha, they began painting in oils. Soon a workshop was formed and other campesinos on the island began painting, until a remarkable proportion of the population was producing pictures. Among those painters whose work was taken by Cardenal to Managua and other cities in Latin America, the United States, and Europe were many women: Rosa Pineda, Rosita Arano, Julia Chavarría, Elba Jimenez, Marina Ortega, Elena Pineda, Marina Silva, and many of the Guevaras. The paintings had an immediate success, and subsequently the proceeds from sales have allowed some of the painters freedom from full-time agricultural work and time to paint.

The overall effect of Solentiname landscape paintings is dazzling and jewel-like; the artists have a superb talent for catching the luminous quality of the tropical forest and for minutely detailing textures of flowers, trees, leaves, birds, and animals. These essentially self-taught artists work with this process: first a basic flowing rhythm is established that suggests the larger shapes of water, land, and sky, and then a careful blending of colors from dark to light produces the intricate surface details and textures of each individual form. The luxuriant island landscape is the most common subject of these painters. However, some artists make narrative compositions too: fishermen with their catch, scenes of a village market, the imagined dwellings of the Miskito Indians, the community welcoming Jaime Wheelock in the newly reconstructed church, and Christ represented as a peasant guerrilla are some examples.

Cardenal based his community on the gospels. After a weekly Sunday mass in a formerly abandoned church, Father Cardenal presided over discussions. Olivia Guevara explained to me:

20. Julio Valles Castillos, *Cardenal*. Painting given to Doña Olivia Guevara.

"We began to analyze our situation, to discover how God manifested, created people with a right to live, to maintain themselves with dignity." As conditions became intolerable in Nicaragua, many people in Solentiname committed themselves to fight the Somoza dictatorship with the FSLN (Frente Sandinista Liberación Nacional). To live as human beings in dignity and freedom, they had to hold rifles instead of paintbrushes. "Every authentic revolutionary prefers nonviolence to violence," wrote Cardenal, "but he does not always have the freedom to choose."

After the San Carlos insurrection, the buildings of Solentiname were destroyed by the Somoza Guardia Nacional: church, communal workshop, library, musical recordings, museum of pre-Columbian artifacts, paintings, along with people's homes. Painting was not permitted by the guardia and had to be done secretly. Some of the peasant painters like Miriam Guevara and Julia Chavarría went into exile; some like Juan Arana were jailed in Costa Rica; others like Carlos García went into hiding in Managua. After the war, many Solentiname artists returned to their archipelago. When Ernest Cardenal became Minister of Culture, he organized painting workshops that sent other artists all over the country to inspire and teach others.

Surrounded by tall trees and dense jungle foliage, the first things you see coming into Solentiname by boat are the stark white box-like church and children's swings and climbing posts painted in bright colors. Nearby, a few cows graze in a fenced-in area. A pathway lined with sweet-smelling flowering plants leads to the large community building, reconstructed after the war with international assistance, especially from solidarity groups in West Germany. The walls of this building are filled with paintings by Solentiname artists. Other white stucco buildings with corrugated metal roofs house a community kitchen, dining room, and visitors' sleeping accommodations; and there are the remains, overgrown with vines, of the former community *taller*, which was not rebuilt after the war.

When I first went to Solentiname, my main objective was to meet with the extraordinary primitive painters and to learn about their art. After many talks with the Guevara family and others from the community, I realized that Solentiname painting was an expression of profound personal and social evolution. I saw the potential we all have to reshape our reality and extend our creativity, as individuals and as a society. Nicaragua could be an example to the world if only it has a chance to develop without the interference of the United States or the Soviet Union. Spiritual and physical freedom are necessary to continuous life-affirming growth.

As I asked questions and listened to the Solentiname artists speak, I decided that their stories could best be told in their own words.

OLIVIA GUEVARA

On the large white walls of her Managua home were reminders of Doña Olivia's Solentiname life [*fig. 21*], in the form of several small landscape paintings and the poster of the Solentiname martyrs who died fighting in San Carlos in 1977. There were two more paintings in progress on table easels beside squeezed tubes of oil paint and brushes. As soon as we began to speak, seated in stately wood and cane rocking chairs, Doña Olivia's Solentiname memories quickened to the surface, and she related to me in detail an account of her childhood, marriage, children, and her friendship with Ernesto Cardenal. She spoke, too, about the heroic night of the San Carlos insurrection, her exile, and her return to Nicaragua.

"The misery, the poverty was enormous. All our lives we lived in poverty and experienced calamities of every kind; there was a lack of everything, food, clothes, no money to buy anything. We used herbs to cure ourselves when we were sick; there were no doctors in Solentiname or money to leave to get one in San Carlos." Olivia and Bayardo Guevara had eleven children. "I had all my children alone, without doctors. Only my husband helped... sometimes we invited a woman friend, if we could, to help.

"We were able to sustain ourselves by growing rice, beans, and corn, although there was much insect plague and it was difficult to grow crops. We mostly traded for the very few things we needed—five eggs for salt, some milk for soap or sugar.

"Sometimes there was school, sometimes not; but I helped teach my children to read and write. The Somoza government got rid of the school in 1971. They were not interested in educating the peasants. Instead of paying teachers, they preferred to pay soldiers to murder them.

"Before Ernesto came to Solentiname in 1966, we didn't know of his existence. Through him our lives, our mentality, our outlook began to change completely. Ernesto Cardenal is from an old bourgeois family. He had some money, enough to buy a hundred hectares of land that included the church on the island of Mancarrón. He gave us work so we could earn fifteen cordovas a day. We cleared the land, and began to build two small bungalows for Ernesto and William Agudelo's family, then a workshop and a community center. Before, we accepted poverty and exploitation with resignation. Then we began to learn from Ernesto about human rights, the right to live in dignity, the right to be a person. From our evangelical dialogues with him we became aware of injustice all over the world. It is important to realize that people are capable of changing, doing something, not just with words but with deeds."

I asked when and why Olivia began to paint. "Ernesto began to awaken in us an interest in painting. This was important for

21. Doña Olivia Guevara with *Solentiname Landscape* (1982).

us. In our family, my son Alejandro was the first one to paint. When Ernesto went to Managua, Alejandro lived in his house; he made his first painting there, and we liked it. Then my oldest daughter María (Marita) began to paint, then Gloria, Esperanza, and Miriam. Ernesto brought more paints from Managua. Then, timidly, I also began to paint. I was timid, but the results were good."

For the Solentiname peasants, painting was to stop abruptly, after the San Carlos insurrection. "On October 13, 1977," Guevara told me, "I had to leave Nicaragua, as all my children were participating in the Frente. We took a small rowboat and crossed the lake to the San Juan River. The boat was full; my daughter with her two babies, another woman with her child, and three younger children. The lake current was very intense. It was a night of much torment. Mosquitoes and other insects bit incessantly. It took me all night to row and part of the next day to reach the Costa Rican border, where we were able to get a ride into San José." For two years they lived there as exiles. "All our children were at the southern front, fighting, except Donald who had been killed in the San Carlos insurrection. The guardia tortured and killed him. He was twenty-four years old."

After the victory of the FSLN in July of 1979, Doña Olivia returned to Managua where she now lives with her youngest daughter Miriam. She told me that they paint almost every morning. "The ideas never leave me. I see the whole archipelago of Solentiname in my head—nature, the countryside, trees, and birds."

MIRIAM GUEVARA

I spoke with Miriam Guevara in the early afternoon one day while she studied for her high school classes. Miriam is now twenty-three, and it was hard for me to imagine her carrying a rifle and fighting, only five years before. She told me about her involvement in the dramatic events of San Carlos.

"A week before October 13th, I left for the commune, a house on a nearby island for three or four days of training—learning how to use guns, machine guns and rifles. There were six of us from the Guevara family, including Alejandro, Donald, Marita, and Gloria. Altogether we were thirteen from Solentiname.

"Alejandro had contact with other *responsables* of the Frente, who told us that we should attack in the early morning of the 13th, as October 12th was a fiesta day in San Carlos, Día de la Raza. No one in the community besides the participants was aware of the plans. Our parents were told only the day before. That night, Alejandro left a light on in our home as if we were there, before joining the others in San Carlos. Seven of us were sent to the main street, the rest to the barracks where the guardia were concentrated."

The attack was to be coordinated on several fronts: Jinotepe, Matagalpa, Masaya, Granada, and other cities. Because San

22. Miriam Guevara with *Transporting Bananas* (1982).

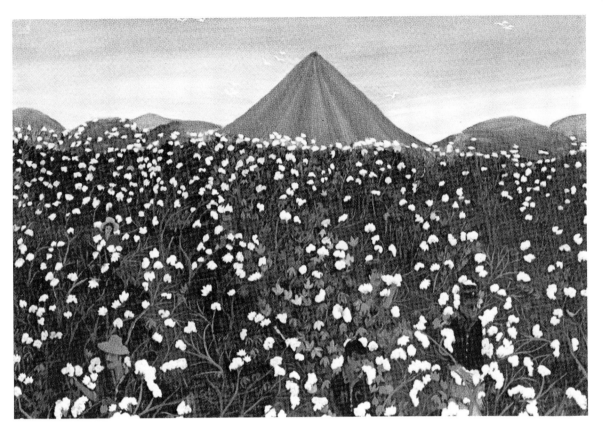

23. Miriam Guevara, *El Algodonal*.

Carlos was isolated, and without radio or telephone, no one knew that the attack had been postponed and the people from Solentiname carried through with the plan.

Miriam remembered the events in detail. "At 4:00 a.m. we went armed to our locations, and at four-thirty, began the attack. By six, Somoza's airplanes were flying over San Carlos. Nine of the forty guardias were killed. By eight, helicopters, more airplanes and soldiers arrived. We continued to fight, but we knew we needed to escape, that they would come with more reinforcements.

"A woman said, 'Go, muchachos, take this boat and go.' We rowed to the other side of the river, left the boat, then walked to the Costa Rican frontier. It took us three hard days of walking, waist-deep in mud. Near the border was a Somoza *finca;* the guardia were in position there, knowing we would pass by. William had more experience; he had been to jail and all. 'If the guardia get you,' he asked, 'do you prefer to be captured or to die?' 'I prefer to kill myself!'"

Before they were finally reunited with Olivia, Ernesto, and others already in Costa Rica, they were kept in detention in San José for a month. "At first my mother thought, from a television program she saw, that we were all dead. Of the twenty-five who rose in San Carlos, three were killed and two were taken prisoner. The men returned to Nicaragua to fight again. The women do other work now, no more fighting."

Miriam said that in Costa Rica she studied radio technology but began to paint again in 1978. "A priest visited us. He liked my work and I sold a painting to him which he hung in his office at the church. That encouraged me to paint more. Now I sell almost all my work."

Inspired by her older sisters, Miriam first began to paint when she was fourteen years old. Ernesto's encouragement helped. "He said, 'If you create a tree or a flower in an ordinary way, consider it more carefully. Paint it better. Paint it with more detail.'" [*fig. 23*]

After their return to Nicaragua, Miriam and her mother helped to form painting workshops in small towns and cities outside Managua and they enjoy sharing what they have learned through teaching. However, they would both prefer to live again in Solentiname.

As I photographed Miriam with her unfinished painting, *Transporting Bananas* [*fig. 22, plate 1*], and admired her *Jaime Wheelock Visits Our Community* [*plate 2*], I sensed that whatever the future brings this young woman who has gone through so much so early, she has a real commitment to painting, to portraying Solentiname as a vision of an ideal reality.

MARITA GUEVARA

Marita Guevara spoke intensely and rapidly about her early life and work. "I was one of the first to begin painting nine years ago, in 1973. I dreamed, I thought about painting when I was young. I drew with colored pencils then. After my brother Alejandro began to paint, I said, 'I also want to paint.' He gave me a small canvas, and helped. I began to look at rooftops, trees, birds. I did my first painting and he liked it very much. Then I wanted to paint bigger. With each painting I explored different themes from our environment and enjoyed the process more and more. After I finished three paintings, I helped my mother and sister learn to paint.

"We formed a group, with seven of us getting together to discuss each other's work. Ernesto, Alejandro, and I were the main critics, but Ernesto was the final critic. We had an atmosphere in our home, too, where we continually discussed painting, until the insurrection. We had to paint secretly and during the war we had to stop. If the guardia saw your paintings, they took them away, and put a knife through them."

Marita believes that "it is not enough just to paint landscapes, but painters must look for themes within the landscape, to include a fishing boat, a fisherman, or a campesino constructing a pier." [Since the revolution] "we use the same techniques and methods of composition as before, but now we try to organize our ideas better. It's important to know what you are painting rather than just to sit down and paint. Still, some just paint simple landscapes."

In her own work, she sometimes chooses a topical subject. In *Viviendo de Miskitos* [*fig. 24*], a painting set in the coastal

24. Marita Guevara with *Miskito Houses* (1982).

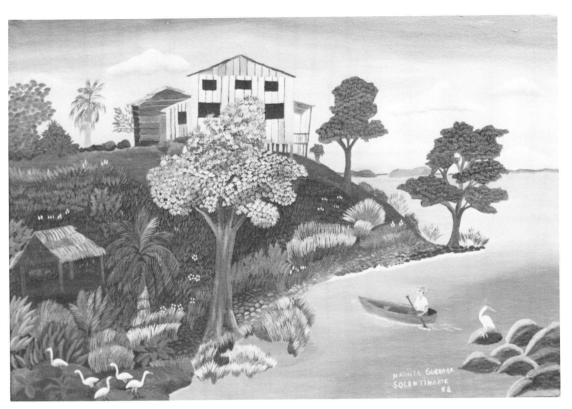

25. Marita Guevara, *The Guevara Family House* (1982).

region of the Miskito Indians which she has seen only in newspaper photographs, she pictures in convincing architectural detail the weather-stained wood frame homes of the relocated Indians. Only the frayed palm leaves, the women's dresses, and a few political posters add bright color accents. In contrast with this somber scene, a painting of her own family home, perched on a hillside, is alight with flowering trees and shrubs in light pastel colors. Each tree and plant is painted in isolated perfection [*fig. 25*].

I asked Marita about the many hours of volunteer work she has done. "I worked in all the reconstruction programs in San Carlos that were set up by the Committee of Sandinista Defense, which has undertaken many community development programs. We worked to improve the availability of drinking water, to start pre-kindergarten schools, and to provide medical care to all. And for several months, each Sunday after church, organized volunteers came out for two hours to clean the San Carlos streets.

Marita has also gone to isolated farms to help organize women. Though there is a growing respect for women in Nicaragua, machismo still exists: "In San Carlos the billiard rooms are filled with men while women wash clothes at the beach. But now there is more opportunity for men to work," she says, and hopes that "in another year there will be a noticeable difference. For me, the revolution is the beginning of everything."

GLORIA GUEVARA

I visited Gloria Guevara in San Carlos where she lives with her husband and two young children. On the front room wall hangs a poster reproduction, printed in West Germany, of her painting *Christ* [*fig. 26*], along with two original Solentiname landscapes painted by friends. She tells me that her painting represents "all men who are sacrificed for social justice, improvement, or for an ideal to be realized for all humanity. Therefore, I painted Christ as a peasant or guerrilla, and painted women, other peasants there, who are crying for him." I saw the painting as a symbolic summation of the joy and sorrow of the Solentiname experience: along with the terrible sacrifice of people's lives, a new awakening."

At a UNESCO meeting in Paris in 1982, Ernesto Cardenal referred to this painting: "Nicaragua is a religious *pueblo*. This is part of the popular culture. In this painting, the biblical story is the same as the story of the people. Jesus is one of us, a peasant, even a guerrilla. The death and resurrection of Jesus is the same as that of the people."

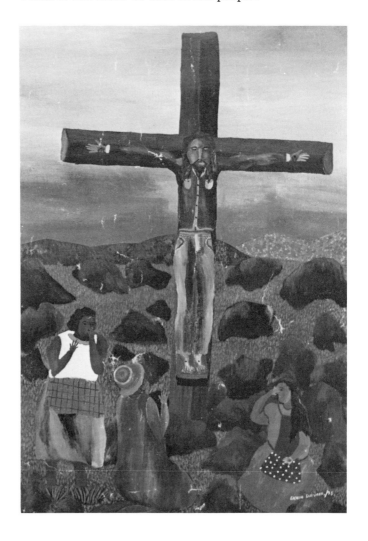

26. Gloria Guevara, *Christ* (1982).

Murals of Country Life
Nicaragua

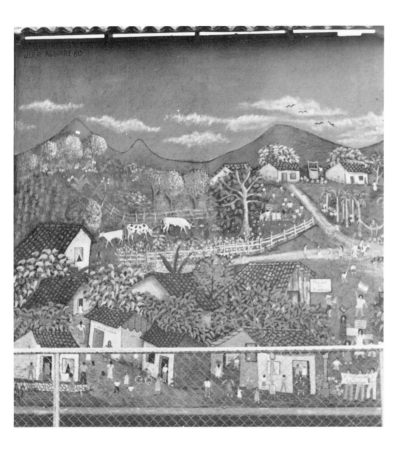

27. Julia Aguirre, *Rural Life* (1981). Mural.

Managua is a wounded city, still suffering from the devastating 1972 earthquake and the recent war years. Amidst the skeletal ruins in the city center is Luis Alfonso Velásquez Park, part of a reconstruction project. The newly planted trees have not yet reached maturity, but the walls of an elementary school in the park have blossomed forth in a variety of colors, shapes, and themes.

Murals painted by Hilda Vogl García and Julia Aguirre cover one of these walls [*figs. 27 and 28*]. The two sections share a unity of design, and bright pastel colors and a mood of optimism and joy radiate from the wall. Both women paint in a primitive style; color is applied to outlined forms, and much emphasis is given to detail by depicting all the leaves on a tree rather than suggesting leaf shapes with impressionistic brush strokes.

The theme of their murals is rural life. Hilda Vogl has painted two scenes: one depicts children playing baseball, and the other a bullfight. Julia Aguirre chose a charming farm landscape. In it, one of the street banners reads *Alfabetización es Liberación* (Literacy is Liberation).

Hilda Vogl explained, "This park was built as an homage to all children, but especially to Luis. He was a very creative child who participated in the revolution. He was ten years old when he was brutally killed by Somocistas."

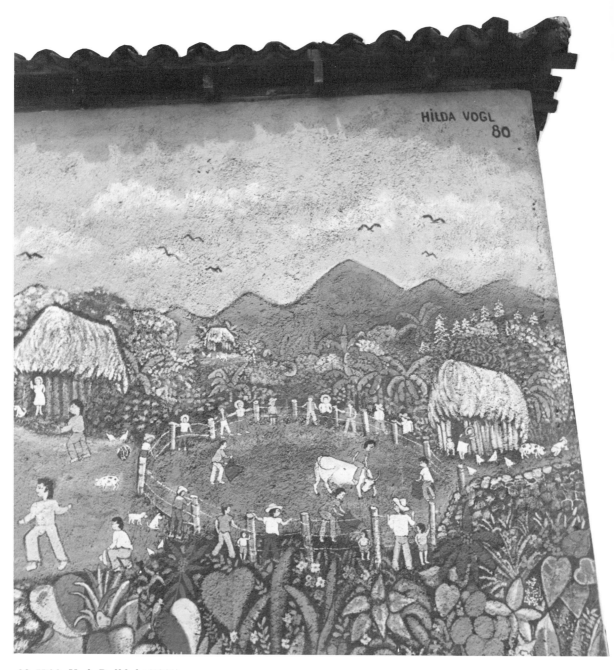

28. Hilda Vogl, *Bullfight* (1981).
Mural.

A challenge for both women, this was their first mural. They received no payment for their time or work, but all materials were provided by the Ministry of Culture. The women painted intensely for two months to complete their work by July 19, 1980, for the first anniversary celebration of Nicaragua's liberation from the Somoza regime.

Reflecting the spirit of today's Nicaragua, murals and billboards connect the country's urban and rural areas through images and messages that elevate social and cultural awareness. Many of these government-sponsored projects emphasize historical consciousness; an example of this are the portraits of revolutionary heroes Augusto César Sandino and Carlos Fonseca. Other popular themes for public art are literacy, health, and the obligations of citizenship. Posters which sometimes are smaller editions of murals are seen everywhere on walls and doors. Even though these projects have a didactic purpose, they nevertheless display a lyric exuberance, in a wide range of contemporary styles, from primitive to realist.

Banners in the marketplace now proclaim new social priorities, especially the militant role of women:

When women are present in the struggle,
their work becomes invincible.
When we become free, we will never return to being slaves.

Though public advertisements for foreign products still exist in Nicaragua's pluralistic economy, their usual sexist format is now restricted by law: "It is prohibited to publicize, distribute, circulate, write, draw, engrave, or paint images or announcements that utilize women as a sexual or commercial object."

Hilda Vogl and Julia Aguirre are proud to be working artists "integrated within the process of social change in the new Nicaragua." I asked them about their backgrounds, the development of their art, to what extent their work was consciously feminist, and how they felt as women in a traditionally male-dominated art structure.

HILDA VOGL

Hilda talked to me about her life. "I first married when I was twenty-three, and as a widow worked to support my three children. I learned to install air conditioners, worked as a sales clerk. It was not until I remarried that I could dedicate myself full time to painting. I began in 1970, after my husband and I and our two sons were forced to leave Nicaragua. My husband is a scientist who could not work under Somoza. [We lived] for ten years in Honduras, Panama, and Guatemala. During this time I began to be so nostalgic for Nicaragua that I started to paint from memory scenes of my childhood and the farm where I grew up. I felt close to the peasants; they also had no education."

About her beginnings as a painter at the age of forty-six she says, "I learned everything alone. At first I painted the poverty of the countryside, in contrast to the image conveyed in advertisements for consumer products, such as Pepsi Cola. The campesinos lived in inhumane conditions. After a lifetime of hard work all they had to show for it was a dilapidated thatch cottage. They suffered from disease and parasites. Now I paint the campesinos as they are experiencing social change, with hope in the revolutionary process." [*fig. 29*]

29. Hilda Vogl (1981)

Vogl, who was able to return to her country in 1979, is very enthusiastic about the impact of the revolution on her own life, saying, "I am happier now than I have ever been. I feel fulfilled as an artist and a mother. My children as well as my paintings are all part of this process of change. When one wants to do something now, it is possible."

A gallery in Miami sells her work, but she also sells paintings through the Cultural Ministry. She is one of some thirty Managua artists who belong to the Unión de Artistas Plásticas, an organization that presents exhibits of members' work. "Our work has been in a number of international exhibitions—in Bulgaria, Czechoslovakia, Cuba, and Germany—and many more are planned. The artist receives the entire price for paintings sold, except for twenty percent used to cover the expenses of packaging, shipping, and publicity. Now the artist has many more possibilities, and art is recognized as an important profession."

JULIA AGUIRRE

Julia Aguirre was married in 1973 to a well known painter who was killed fighting with the Frente in Granada. They have one child. She told me, "In 1973 I began to play with color and became serious about my painting in 1974. I have since participated in many exhibits: Primitive Painting of Central America, in a Florida gallery and in exhibits organized by the Cultural Ministry." I asked when she had time to paint. "I live with my mother, and my child goes to nursery school. I have enough time. I make small drawings or sketches first on location in the street or in a house and then I paint from these sketches. I paint every day. I enclose myself to work and don't need food, conversation, or anything until I'm finished. Painting absorbs me completely.

"The Artists' Union has helped me through discussions, an interchange of ideas, knowledge of materials, and towards developing self-criticism. If you have a relationship with other compañeros, you can learn from them. An exchange of ideas is important to let you know if you're progressing or stationary. The Artists' Union and the Cultural Ministry try to create a better public awareness of art, to show art to the people of Nicaragua, as well as showing the work of Nicaraguan artists to the outside world."

I wondered if women's art is considered as important as men's in post-revolutionary Nicaragua. "Now more women are working as artists. Since the triumph of the revolution, people have more opportunity to develop. Only men painted seriously before. Women's work was not considered important. Women were marginalized. The Somoza government left us a poor inheritance. Now women also can develop as artists, and they must learn to advance their art just as men do."

María Gallo

María Gallo's calm expression soon becomes intense as she speaks about the role of women in Nicaraguan society in relation to her own goals as a painter [*fig. 30*]. One of the few women whose work is represented in national art exhibits, she is unique in a male-dominated profession. The theme of her work is Woman, and she paints from a feminist perspective.

In order to reach María Gallo's small house and patio-studio where she lives with her father and sister, one has to pass by many streets filled with the stalls of the sprawling Mercado Orientale, Managua's largest market, which never closes. The market vendors, mostly women, come before dawn, carrying enormous bamboo baskets of fruits and vegetables which they set up in the wood stalls or on the stone-paved street. Women "carrying baskets as an extension of their round, strong bodies, as symbolic of the market women, the women of life:" these are the images María Gallo uses in her work.

Gallo turns for inspiration to her country's pre-Columbian heritage, to the "beauty and strength of stone sculpture." Her female forms are related to this solid feeling of ancient stone. However, she suggests that the women of the Mercado Orientale are also heroic, as they "take charge of their own lives, often raising their children alone, always fulfilling their responsibility as well as evolving and changing through the revolution."

In her paintings the rough feel of stone is achieved through the preparation of the canvas surface with a thick textural base of sand and other materials applied with a spatula. Her painting *Earth Mother* [*fig. 31*] is an example of this process. Here the curved form of the mother, holding ears of corn in her lap, is simplified as if carved from a solid piece of stone. María Gallo has never been able to paint full time. Her parents did not encourage her to pursue art as a career; her father, who drives a taxi, felt that school should prepare her for earning a living. For several years she worked as a secretary; but in 1972, when she was 21, she determined to study art at the National Fine Arts School, where she was the only woman student. She recalls that the faculty demanded the same quality of work from her as from the men; the painter-teacher Carlos Montenegro was especially important in giving her encouragement and confidence in her work.

During the revolution, in 1978-79, it was impossible for her to continue painting. She cared for her hospitalized mother and helped nurse the wounded. Her brother was killed fighting with the FSLN and shortly after, her mother died of heart failure. "Emotional suffering related to war also kills people," she told me.

Immediately after the war María began to work with the Ministry of Culture, first as an art teacher in a Center in Sandino City, a district of Managua, and, after 1981, as coor-

Mothers and Masks: Two Painters
Nicaragua

30. María Gallo with *Portrait* and *Folk Dance* (1982).

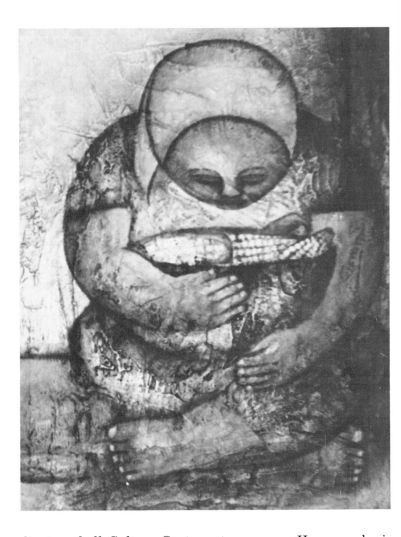

31. María Gallo, *Earth Mother*
(1981). Oil on masonite.

dinator of all Culture Center art programs. However, she is often not at her desk in the Ministry, but visiting the sixteen centers all over the country to "see and know what is being done, to offer workshops, mount exhibits and promote art so that it is accessible to all levels of the population, including housewives, peasants and factory workers." She also brings exhibitions by professional artists to the rural areas. Travel and meeting all kinds of people, she says, have given her a better understanding of "the beauty of the *pueblo*" and a new consciousness of her pre-European roots. Participation in the National Artists Union gives her a sense of professionalism and solidarity with other artists.

María Gallo says, "I am learning now about my *pueblo,* an extraordinary land that has suffered much, one that is not too well developed but is in the process of creating its own new future.... We are rediscovering our own feelings and giving them importance. Artists are no longer interested in producing bright, superficial or picturesque paintings for tourists, as in former years, but are seeking to work with a true depth of feeling, an authentic Nicaraguan spirit."

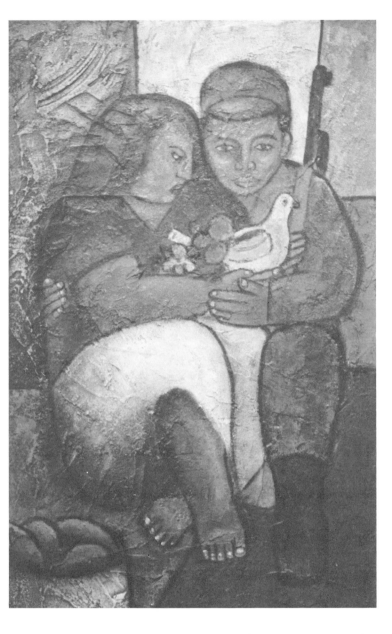

32. María Gallo, *Love* (1983).
Oil on masonite.

María Gallo and Julia Aguirre are the two women artists participating in the exhibition United Front Against Aggression at the Casa Fernando Gordillio. Gallo's painting *Love* [*fig. 32*] adds a tender and intimate dimension to the exhibit's theme: two figures, a young woman and a man in military uniform, seem to merge as together they hold a bird in their hands.

Time for painting is limited to weekends and nights, but Gallo works as often as she can, using two bright lights in her outdoor patio-studio. "My most important ambition is to continue developing as an artist, to leave a body of work as a testimony of all that I feel and have learned about my people, and as a woman."

CECILIA ROJAS

As a young woman during the Somoza dictatorship, Cecilia Rojas found teaching one of the few professional careers open to her [*fig. 33*]. Her father died when she was ten and her mother kept the family together by working as a house servant. After twelve years of teaching elementary school and raising two children, Rojas decided in 1978 to re-enter school as an art student. At the same time, she taught two painting classes at the school to contribute to the support of her family. In talking with her about the situation of women artists today in Nicaragua, she told me that "even since the revolution, with tuition and art supplies provided free by the government, it still is not easy for women and especially women with children to study art because their economic maintenance is a problem."

Her painting *Literacy Campaign* [*cover*] was inspired by documentary photographs of Nicaragua's postrevolutionary literacy program in which she participated—"one of my most formative personal experiences." For the first time, thousands of young students and teachers went into the countryside to teach campesino families the basics of reading and writing. *Literacy Campaign* portrays a tender relationship between teacher and learner, each with masked face hovering over a book. A strong linear rhythm, as well as a three-dimensional or sculptured quality, is created by the dark outer edge of each simplified form—sombrero, torso, book or mask—as colors are blended smoothly from dark to light. The drama of her themes is amplified by the use of partially visible body forms that support the huge masks which dominate the canvas.

Cecilia Rojas chose to paint masks, she says, because at the age of thirty-five she is "too old to develop the technical capacities for realistic portraiture." However, there is no doubt that her masks give her work great originality and power. The mask itself goes far back in Nicaraguan history. Traditional masks that portray the forces of good and evil as well as figures from folk tales and myths have long been worn in festivals and Saints Day celebrations throughout the country. Masks are also used in public dramatizations of the Spanish conquest. And the revolutionaries of the 1978-79 Masaya insurrection against the Somoza dictatorship wore masks to prevent reprisals against their families by the National Guard.

Nicaragua's pre-Columbian Indian heritage is one source of Rojas' painting *The Other Me* [*fig. 34*], in which she contrasts the grey metal mask of a guardian or protector spirit with the red ochre face of a *combatiente,* or soldier. Relying less on heavily applied and textured pigments used by many professional artists, she carefully blends warm yellow and red ochres and juxtaposes them with the deliberately cool dominant tones of grey blue and blue-greens. The simplicity of her carefully selected and designed forms is brilliantly integrated with color and meaning. A deep blue background surrounds and unites

33. Cecilia Rojas at the National Fine Art School, Managua (1984). (Painting incomplete).

34. Cecilia Rojas, *The Other Me*
(1984). Oil on masonite.

the lighter tones of the two masked forms, one facing the
viewer and the other looking away. The smooth curves of the
darker mask bring into prominence the pointed edges of the
metal mask supported by the irregular contour of a sleeved
arm. There is a timeless quality in the hollow eyes that face
us, and the partially closed profile-eye of the warrior. About
this painting, Rojas spoke to me of "the pain of knowing and
feeling that so many of our young people are dying in an unjust
war, and we hope that our children will have it easier."

Piñatas
of War
and Peace
Nicaragua

35. Emilio Ofuentes, *Helicopter*
(1981). Piñata.

There are no written records that document the history of
piñata making, but there is general agreement that piñatas
have always been related to communal celebrations or fiestas.
Some Latin American historians believe that the piñata ritual
began with the Mayans who suspended large gourds containing
fruits and nuts. Others feel that this custom originated with
the Spanish colonizers who used them at Christmas celebra-
tions to commemorate the birth of Christ. Still another inter-
pretation more broadly compares the piñata to a womb and the
releasing of its contents to the birth of a child. Piñatas are still
in popular use throughout Latin America, particularly for
Christmas and birthdays.

The piñata is initially composed of an inner form, or claypot,
which is then covered with cut, shaped and taped cardboard
which gives it a specific form—usually a chicken, rabbit, cow,
or other animal. The outer layer consists of folded, overlapped
and fluffed tissue paper glued to the cardboard surface.

The piñata suspends from a rope that can be raised or
lowered, controlling its accessibility to stick-carrying, blind-
folded contestants who take turns striking wildly, as each
attempts to deliver the final blow. Young and old are eager
audiences during the period of playfulness and suspense prior
to the piñata's ultimate destruction that releases an assort-
ment of candy, peanuts and fruit. When this happens, everyone
cheers, and a stampede begins. Grabbing is the method that
best describes the chaotic rush to acquire a portion for oneself,
but in spite of all the aggressive behavior, there is sharing and
a good time for all. The breaking of a piñata can take a few
minutes or can be prolonged, depending on the skill, experi-
ence, and luck of the participants.

No matter how beautiful or innovative in design, all piñatas
are destined to be broken open. When I see piñatas, I think of
the life cycle: birth, or the initial delight of seeing the piñata;
the life span, or the wild dance of the piñata as it is manipu-
lated by the rope; and the piñata's death that is both a sad and
a joyous release.

The unique piñatas of Daysi Delsocorro and Emilio Ofuentes,
brother and sister from a Monimbó family of artisans, make a
political statement. Their piñatas are enormous in scale and
express the joy of peace as well as the destructive memories of
war. Daysi makes life-size joyous clowns that seem to enhance
the new Nicaragua, while Emilio's helicopters and airplanes
recreate the terror of falling destruction from the sky [*fig. 35*].

About the age of six, all four children in the family learned
to make piñatas from their mother. Now only Daysi, sixteen,
and Emilio, twenty-four, still live at their combined home and
studio, where they work from 8:00 a.m. to 4:00 p.m., their
newest piñatas hanging above the doorway. They say, "we create
whatever figures people want and we make them by the dozen."
Another piñata in current demand has a human shape: the
guardia de Somoza. This one is related to a historical practice,
described by Doris Tijerina in *Inside the Nicaraguan Revolution*

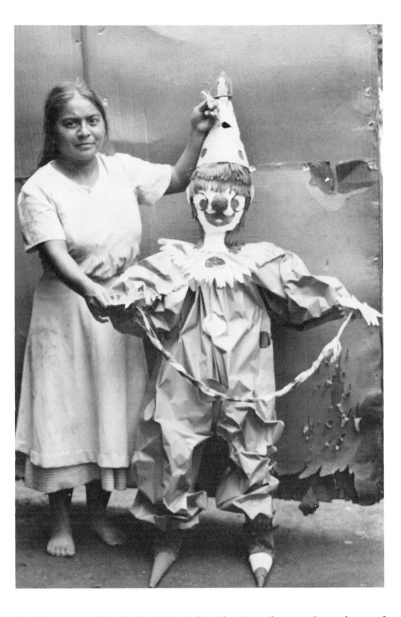

36. Daysi Delsoccoro, *The Clown* (1981). Piñata.

by Margaret Randall: "At night [during the war] we burned effigies that symbolized repressive elements. This is a tradition of the Nicaraguan people—representing the persons who repress and exploit them. This is done by means of an effigy that is paraded through the city before being burned." An adaptation of that tradition, the Delsocorro piñatas are meant to celebrate solidarity, victory, and freedom.

Daysi's smiling clown of peace [*fig. 36*] with outstretched arms made me think of Ernesto Cardenal's 1982 UNESCO speech, in which he defines Nicaraguan culture as a culture of peace: "The earth is round. This also signifies that as our human population continues to grow, people will have to continue reaching their hands out to others until humanity evolves into a new species: one great planetary organism."

Otomi Indian Weavers: Change and Innovation
Mexico

My life became intertwined with the Otomis for one year, 1955, when I was hired by the PIVM, Patrimonio Indigeniste del Valle de Mesquital, a United Nations-sponsored, Mexican government organization, to paint murals on three new but remote Otomi Indian village schools [*fig. 37*]. I also taught there, and as I painted, drew, and photographed, I became ever more attracted to this traditional way of life and especially to the textile weaving of the women. For many centuries they have woven *ayates*—carrying-cloths—and drawstring bags, but only in recent years have they designed them to carry textbooks instead of tortillas.

The culture of the approximately 300,000 Otomis in the Valle de Mesquital is based on common land, language and traditions which were essentially undisturbed by Spanish colonizers. However, since 1952, the culture has rapidly been succumbing to the government's efforts to bring indigenous cultures into the political and economic mainstream. This has changed not only what, why, and how women weave, but the entire Otomi way of life.

37. Betty LaDuke with Otomi women at Patria Nueva, Mexico (1955).

38. Juana Daroteo taps maguey cactus, San Juanico, Mexico (1955).

The once arid Otomi valley, located approximately two hundred miles north of Mexico City in the state of Hidalgo, was described by Antonio Rodriguez as "the valley of the sterile clouds;" but, after completion of a dam in the 1960s, it is fertile and green with abundant crops of alfalfa, corn, beans and chile. The economy, now based on wage labor and consumerism, used to be primarily dependent on the cultivation of a single plant, maguey cactus. This plant was the Otomis' staff of life, providing the beverage *pulque,* ixtle fiber, and roof thatch [*fig. 38*]

Through production and sale of drawstring bags, *ayates,* and rope made from ixtle, the Otomis received cash to buy beans, corn, and chile, which few could grow themselves. The entire family contributed. The men usually cut and pounded the maguey stalks, breaking the firm outer layer to release the white ixtle fiber. Men, women and children of all ages carried

spindles almost as permanent attachments to their fingers, spinning as they walked to the distant market, to fetch water, or even to visit a grave.

Ayates, multi-purpose, square pieces of loosely woven cloth, about thirty-six inches square, serve many practical needs. Suspended from the head by a narrow band, with the lower two corners knotted together, the *ayate* forms a backpack for transporting produce and children. A folded *ayate* is also used as a head covering. Most Otomi men traditionally wore two *ayates* criss-crossed over their chests and backs. At home, babies were suspended in *ayate* cradles. *Ayates* were also folded and stitched along the bottom and sides to form *costales,* or produce bags.

In some villages, women specialized in weaving on backstrap looms drawstring bags, about eleven by fourteen inches in size, utilizing the natural ixtle combined with dyed magenta, blue, or red wool or cotton thread. Traditional motifs such as bird, flower or animal forms, and sometimes even the month and year, were incorporated into the two-color weaving pattern. The drawstring bags were used mostly by the men to carry lunches of tortillas and chiles when they worked away from home.

The bags, *ayates* and rope were purchased by mestizo merchants or entrepreneurs on market day, who then transported them in trucks to Mexico City where they were profitably resold. These merchants controlled or fixed the minimum price paid to the Otomis, a bare survival wage for their labor.

When I returned to visit my Otomi friends in 1975 changes which had just barely begun during my stay were now fully visible, and affected the entire culture. In San Juanico, I was warmly greeted by the Tiburcio Daroteos, who still remembered me after more than two decades. After sharing a meal with the family, which had grown to include Juana, Tiburcio's second wife, and their nine children, I surveyed the town with Tiburcio, now seventy-nine, who was almost ecstatic with delight and pride as we viewed the "progress." His extensive garden contained a variety of fruit trees, vegetables and bee hives. His four acres of land, now irrigated, produced corn and alfalfa. A fat pig lay in the shade of its pen nearby. His family also had a new cement floor, stucco wall, one-room house with beds, instead of mats. The one-room schoolhouse where my mural was painted on the outdoor patio wall was now expanded to six rooms, children were encouraged to attend school, and most adults and all children now spoke standard Spanish. There were new maternity and health clinics with resident nurses and doctors. Traditional clothes were now worn only by some of the older generation. Soon the Otomi way of life would be indistinguishable from that of the mestizos.

Juana was no longer weaving *ayates.* Only a few women, primarily from the village of San Nicolas, still created traditional bags and other woven items [*fig. 39*]. In this village, near Iximiquilpan, I visited Inez Ybarros and her family. Inez

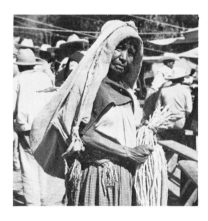

39. Inez Ybarros selling rope on market day (1955).

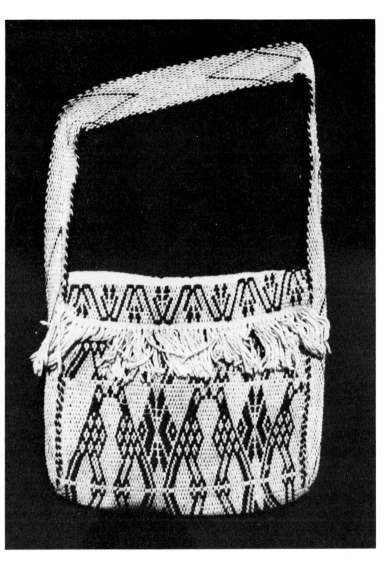

40. Otomi shoulder bag to accommodate books, San Nicolas (1978).

has taught her two daughters-in-law, María and Georgia, who come from different villages, to weave the traditional Otomi designs on backstrap looms. Inez, who is sixty-nine, awakens at five each morning to spin wool for one hour before making breakfast for herself and her husband, who is now too old and ill to work. She then takes the sheep to pasture for the day and upon returning in the late afternoon, continues spinning wool. Most of this yarn is sold to other families who use it for blanket weaving. Inez feels that her eyes are too weak to concentrate on weaving, but she is proud that María and Georgia will carry on the tradition.

The bags they weave now have a broad shoulder strap and a flap to cover the wide opening [fig. 40], instead of the old drawstring [fig. 41], so they can accommodate textbooks. Carried by Ixmiquilpan secondary school children in blue jeans, these bags are small visible reminders of Otomi culture.

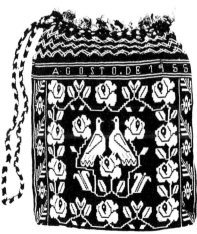

41. Otomi drawstring bag (1955).

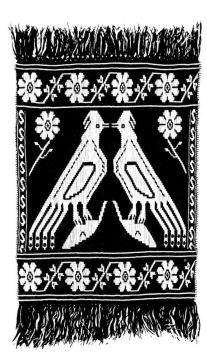

42. Otomi traditional weaving designs for placemats (1978).

Each day María and Georgia weave as many hours they can, usually in the interior of the house while their babies sleep in suspended nylon *ayate* cradles, lulled by the sound of television programs. They take pride in their work, but they are also glad to be able to buy factory-made, stylish clothes and shoes.

Instead of selling their weavings individually at the weekly Ixmiquilpan market, a group of fifteen San Nicolás weavers have formed a cooperative. Only one woman is responsible for bringing all their varied woven products to market, displaying and selling them. Other opportunities for sales exist, for the PIVM has organized a government store where the women can leave their work on consignment. Except for a small commission, they receive the full price they themselves establish for each item.

In recent years, wealthy and middle class Mexicans escape the congestion and pollution of Mexico City in Ixmiquilpan where they enjoy nearby mineral springs and baths. These are the main tourists who buy Otomi hand-woven products. The weavers accommodate urban needs by applying traditional designs to place mats, table runners, vests, and shawls [*fig. 42*]. In recent years some weavers have been receiving private commissions for their work from United States and French exporters; this has encouraged the continuity of the craft, which had almost vanished with the old self-sufficient economy. The PIVM, recognizing a potential cultural loss, established adult education classes where young people could learn the designs and techniques from the few remaining older weavers. That is how Erlinda, a neighbor of Inez Ibarra, learned to weave and it seems likely that she will teach her future children this skill.

I hope that Otomis, with all their new prosperity and mainstream progress, will preserve traditional values and be able to determine for themselves what should not be lost. As we all move towards a plastic world mono-culture, the Otomi heritage as well as that of all indigenous peoples becomes absolutely invaluable. More recent trips to Mexico, after 1980, have reinforced my belief in the importance of the weaving tradition to the survival of Otomi women's prestige and power. Though weavers have had to accommodate themselves to new goals, needs, and marketing procedures, their creative energy remains vital. By learning to speak Spanish, these women have become less dependent upon the men for marketing their work, and through organizing, they receive a fair compensation for their creative products. They are an inspiration to their children as well as for others outside Otomi culture.

In June of 1982, I met with Fanny Rabel and Susana Campos at Rabel's home, which resembles a miniature art gallery and museum of Mexican folk art. During the evening we enjoyed discovering we had much in common as women and artists.

Although Rabel's work is figurative, while Campos' is abstract, both women share an exuberant energy that manifests in spontaneous development of the image. Full time artists, both have been married to artists; and they are free from domestic burdens. The two of them agreed that although machismo and sexist discrimination are widespread, especially in marriages, these attitudes had not had an adverse effect on their own educations or their participation as professional artists within the gallery system, where their works are frequently shown.

They are aware of their special advantages as well-off urban artists; Fanny laughs as she says, "even my paintbrushes are washed for me!" Nevertheless, she shares with Susana a political commitment. Both women participated in the 1979 Nicaraguan Solidarity Exhibit, sponsored by Mexican artists to raise money to support the efforts to overthrown Somoza. They are concerned, too, with widespread human rights violations throughout the hemisphere. Like many other Mexican artists, they have been turning to Latin America as a source of inspiration rather than to the United States or Europe.

Painters in Mexico City
Mexico

FANNY RABEL

Fanny Rabel, at fifty-eight, is one of the most renowned Mexican artists of her generation. She was born in Poland, but since the age of fourteen, Mexico has been her home. In addition to her training in Mexico City's art school La Esmeralda and the Taller Gráfico Popular, she studied and painted murals with Diego Rivera and Frida Kahlo. She has supported herself through sales to the government, as well as to the many private galleries that have proliferated in Mexico during the past two decades. In 1951, she was a founding member of the government-supported gallery Salon de Plástica Mexicana. She has had numerous national and international shows, as well as a major book, *The Painting of Fanny Rabel* by Enrique F. Gual (1968). Her work is in the collections of New York's Museum of Modern Art and in those of French and Danish museums.

Rabel is one of the few women in the male-dominated field of painting to have had the opportunity to design and execute five of her own murals. The best known of these, *La Ronda en El Tiempo (The Circle of Time)*, painted in 1968, shows a large group of children with arms extended toward one another. It is seen annually by thousands of people at Mexico City's Museum of Anthropology. Fanny Rabel says of the process of painting, "When I paint, I am an artist. I don't know whether I'm a man or a woman."

43. Fanny Rabel, with *Planners*, Mexico City (1981).

44. Fanny Rabel, *Pollution* (1982).

The universal appeal of children distinguishes Rabel's early oil paintings, portraits of her own two children. Indeed, children have often been her subjects. Although her later portraits of *inditos,* Indian children, are always a popular and commercial success, she has also explored a wider range of personal, environmental, and political motifs.

Speaking about her large 1981 painting *Planners* [*fig. 43, plate 3*], she comments sarcastically, "Mexico plans and plans, but all plans rob money from the people and don't change anything." In this large canvas, she contrasts the roles of rich and poor, portraying a lace-gowned woman in a flower-trimmed hat who presses her hand down on the head of a seated woman in a brown robe.

Rabel routinely works at her studio, a small room built above her apartment overlooking the smoggy horizon. This view has inspired another group of paintings called *Pollution* [*fig. 44*]; in one of them, she depicts in dark somber tones a dense, immobilized conglomeration of people and cars amid blinking traffic lights.

45. Fanny Rabel, *Trapped #1* (1982). Drawing, mixed media.

In contrast to the children's portraits and murals which are aligned with socialist realism, Rabel allows room for the expression of freer, more personal pictures. In a series of drawings from 1978-79 called *Trapped* [*fig. 45*], the trapped forms seem to emerge from spontaneous drips and splashes of enamel, oil and water-based pigments. Long chains of people, as if suspended in droplets of water, reach out and cling to one another as the chains diagonally crisscross the width of the page. In

46. Fanny Rabel, *Trapped #2* (1982). Drawing, mixed media.

47. Fanny Rabel, Poster to publicize the disappearance of Alaíde Foppa (1982).

another drawing from this series [*fig. 46*], a seated woman dominates the lower area. Held aloft are claw-like hands, outlined in pen and ink. Within the body, four heads are stacked like a totem pole; the impact of this drawing is great. To me it suggests aspects of the archetypal mother, at once protecting and controlling her children.

In an earlier series of oil paintings, begun in the 1970s, she used thick layers of paint, allowing intense images to arrive at the surface as if part of a peeling, cracked adobe wall that might have witnessed the birth and death cries of countless generations. The thick and crackled appearance of the surface, suffused by soft white and pale colors that partially veil the deeper-toned underlayers of the figures and faces, tempt the observer to touch these canvases. *The Immigrants, Fear,* and the *Voiceless Scream* are some of the titles of these frightening, melancholy images.

In a review of Rabel's work in the Mexican newspaper *Excelsior* the Guatemalan writer and art critic Alaíde Foppa wrote: "Fanny Rabel, formed within the foundation of Mexican realism, and the Popular Graphic Workshop, that is to say, within a movement that aggressively waves the banner of social realism, has managed to escape entirely the dogmatic expressions of this school and cross over to a lyrical style which nourishes her painting."

Speaking for her commitment to victims of political repression, Rabel recently created a poster to publicize the disappearance of Alaíde Foppa [*fig. 47*]. Foppa had been exiled from Guatemala in the mid-1960s because of her outspoken political views. She subsequently moved to Mexico, taught at the National University, hosted a weekly radio program on women's issues, and wrote art criticism. While risking a return to Guatemala to see her mother in 1980, Foppa was pulled out of a car and never seen or heard from again, becoming another statistic on the growing list of Guatemala's "disappeared ones."

SUSANA CAMPOS

There is a remarkable transition from Susana Campos' early work, for example, the still self-portrait painted in 1960 [*fig. 48*], to her more recent paintings and prints which show a torrent of released energy and abstract movement. Susana, an only daughter in a family she describes as "middle class and conservative," had to overcome her parents' opposition in order to study at the San Carlos Academy of Art at the age of sixteen. During three years of formal study, from 1962 to 1968, her emphasis was on traditional figure drawing and painting, but by the end of her third year she knew she wanted to do something different.

Married in 1966 to an art student, Campos and her husband went to Paris on art scholarships in 1968. Besides studying printmaking at the Hayter workshop and exploring innovative etching techniques, they also traveled through Europe, visiting museums everywhere. At this time Campos began to break away from the figure; rhythmic, circular and flat abstract shapes became central to her prints, oil paintings, and line engravings on plastic [*figs. 49, 50*].

In conjunction with her 1975 one-woman exhibit at the Salon de la Plástica Mexicana, Susana outlined her aims as a painter: "To give free reign to my hand; to permit the fluid lines, curves and rhythms that express a vital lyrical feeling as a testimony to my way of being; to demonstrate an open elasticity of curves and colors; to give priority to my feelings without departing from a rational means of composing; and to free myself from the coldness of geometry. . ."

48. Susana Campos with *Self-Portrait* (1962) in her Mexico City studio (1982).

49. Susana Campos, *All the Earth* (1982). Engraving on plastic.

50. Susana Campos, *The Lonely Ones* (1982). Engraving on plastic.

Susana's studio is a small apartment, where she paints every morning while her two young children are at school. Grateful for the time she has for creative work, she told me, "I give my complete self to my art. If I had to work, take care of children and a house, I couldn't paint or produce prints."

Susana Campos had her first solo exhibit in 1967 and has continued to exhibit and participate in many group shows in France, Chile, the United States, and Argentina. Her work is sought by galleries; sales of her work are substantial. She speaks enthusiastically about plans for a government and artist-sponsored Center of Culture in Mexico City that would be a "living museum," where artists from all over Latin America who are threatened by growing militarism and persecution can come to live and work.

Raquel Tibol assessed her *Rhythm* show in 1981: "Susana Campos is established as a very original cultivator of space, for her sense of structure, her obsessive and futuristic tendency toward kinetic movement, for her suggestive reference to the human form and rhythmic and lyrical configurations. She surges ahead, well before man's conquest of space, toward a universal immensity that permits the coexistence of interplanetary spaceships with the stars, a cosmic dance through the imagination of a sensitive Mexican artist."

A year later, I was invited to Fanny Rabel's studio again, this time to a dinner party with Susana Campos and nine other women friends. It was a cool stormy evening, and as we warmed ourselves with rum and coke and hot quesadillas, the conversation turned to our concerns as women artists.

They told me that in Mexico the women's movement had not evolved beyond a small elitist group. Extreme class differences, the disparity between urban and rural women's needs, the conflicting perspectives of Indian and ladino women, and fear that identification with feminism would lead to ridicule and ostracism were some of the reasons they gave. Factionalism and lack of a coherent philosophical base, they said, were additional problems.

However, some positive changes were taking place. Some Mexican artists had become interested in the directions feminism was taking in the United States and France. Monica Mayor, a prominent feminist artist, told us of her recent activities. She had studied in Los Angeles and had been impressed with Judy Chicago's historical explorations; and now she herself had uncovered over four hundred Mexican women artists of the past whose work was virtually unknown. After much struggle, Mayor had finally had a Women and Art course accepted at the National Fine Arts School; and although only eight women had so far risked this new adventure, she was hopeful that enrollment would grow, and with it, a new awareness of women's achievements in the arts.

During the summer of 1982, thousands of Indians and peasant farmers were killed—and thousands more forced to become refugees—by Guatemalan government troops in a bloody "antisubversive" campaign in rural areas. Reports of whole villages of beheaded Quiché people continued to appear in the press, to the chagrin of a United States president anxious to resume military aid to the government. However, the tourist booth in the Guatemalan airport was attended by a smiling woman who assured me that it was safe to visit the rural areas, including Santiago Atitlán, since the buses were now operating on schedule. The "incidents" had subsided, she said. Her assurance was not confirmed by my plane companion, a young Guatemalan businessman who confided that the only way he would venture outside the city limits would be in an armored car! His parting advice was to be very careful.

The purpose of my trip to Guatemala was to visit a family of weavers in Santiago Atitlán, from whom we had purchased a special piece of beautiful handwoven and embroidered cloth during our family Christmas vacation four years before. On this lovely textile, superimposed on alternating pale blue and deep red stripes, are dozens of birds in multiple colors, all hand embroidered. Each bird is unique in design and some have long tail feathers like the quetzal, Guatemala's national bird. Originally made to be half a side of a man's pair of trousers, it now hangs flat on a wall in our house, a joyous visual memory of our encounter with the Quiché Indians, whose rituals and traditions still remained miraculously alive in 1978.

I wanted to see the woman who created this cloth again, to see what she was now making, and I feared what I might learn about what had happened to her family and her town. When I arrived, Concepción's door was wide open, and the walls of the front room were entirely covered with the *huipiles* and traditional clothes that she and her mother produced together. They were surprised and glad to see me, placing into my hands each wonderful piece of cloth at which I glanced. I was amazed at the quality of these new textiles, inconceivably detailed and crowded with multicolored patterns of birds. With almost no space between them for an imagined flutter of wings or fantasy flight, they seemed almost immobilized. I was simply awed by their splendor.

Concepción, like most of the women of Santiago Atitlán, a town of 8,000, works six or seven hours a day spinning and dyeing cotton fiber before weaving it on back-strap looms which are set up in the courtyards of the home [*fig. 51*]. Vera Kelsey in *Four Keys to Guatemala* describes how the weaving of cloth, an ancient art of the early Mayans was begun many centuries before the arrival of the Spaniards. In the highlands, Guatemala's six million Indians, whose language and tribal traditions endure, spin and weave just as they have through centuries with few technical changes [*fig. 52*]. The creating of cloth has been not only a practical art, but it was a religious experience. In years past, before a weaver began to work she

Pastel Birds and Khaki Uniforms
Guatemala

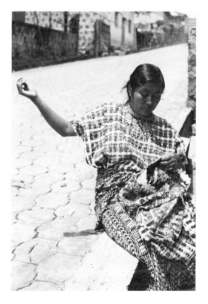

51. Concepción embroidering a *huipil*, Santiago Atitlán, Guatemala (1982).

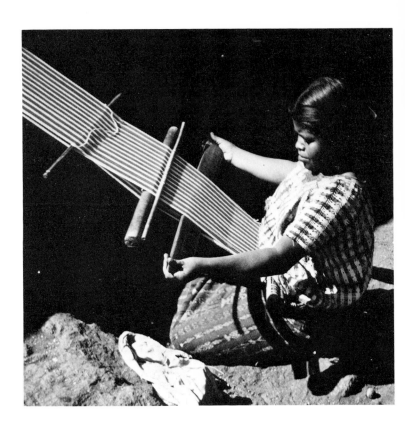

52. Weaving with a back-strap loom, Santiago Atitlán (1978).

offered a prayer and lit candles for her patron saint. If part of her personal wardrobe had to be sold, it was first hit with a stick to make sure that no part of the weaver's spirit would depart with it. These Guatemalan weavers were never anonymous, and each wove an identifying symbol into a corner of the fabric. No traditional textile was ever completed without a small flaw, because perfection could be considered an offense to the gods. Because each isolated village developed its own unique patterns and styles, weaving was also a symbolic language. A person's village, social class, descent, and marital status could be determined by the garments he or she wore [fig. 53].

With the increase in tourism, women found that they could earn more from the sale of traditional textiles than men could from seasonal agricultural work, and they began to depend on urban buyers [fig. 54]. In many cases, increased production resulted in modifications in weaving techniques with an emphasis on speed rather than elaborate design. The needs of outside markets were evident, too, in shops in Panajachel where backpacks and sundresses were displayed in profusion, along with traditional garments [fig. 55].

However, in a tragic irony, the situation had now reversed. Concepción explained that during the past four years buyers had come from European countries to Santiago Atitlán to purchase textiles for resale abroad where people appreciated fine traditional work and were willing to pay for it. And so

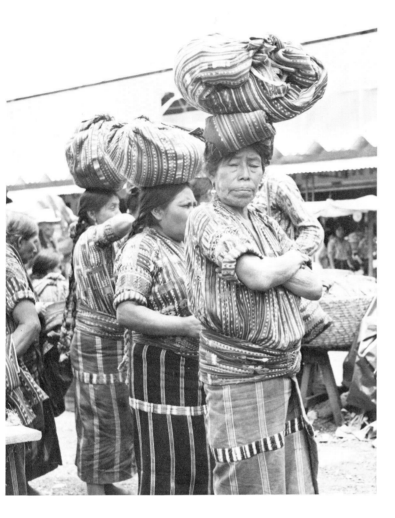

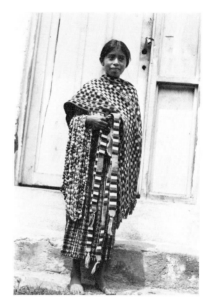

54. Child selling woven belts, Santiago Atitlán, Guatemala (1982).

these beautiful pieces, especially the stripped cloth, had become even more richly detailed. But now the terrible violence between government troops and peasant guerrillas had stopped travellers from coming to Guatemala. For some of these Indian weavers, there was now less food, for others the situation was even more desperate. People were lucky just to stay alive. Concepción would not talk about the political situation, and everywhere I went I was warned, "be careful of whom you ask questions!"

I left Guatemala, carrying with me another of Concepción's brilliant textiles, but this time her cloth with its beautiful pastel-colored embroidered birds would always be accompanied by the memory of thousands of khaki-uniformed soldiers—and townspeople and peasants whose lips were silent with fear.

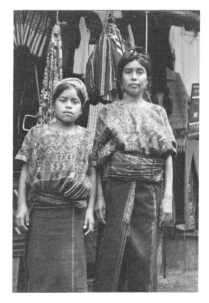

55. Market woman with her daughter, Panajachel (1982).

Refugee Children's Drawings
Guatemala

56. Kiki Suarez with Guatemalan children's drawings (1983).

Pictures drawn by Guatemalan children living in refugee camps along the Mexico-Guatemala border raised the question, "What can we do?" I felt such compassion and anger that I wanted to speak with the children and their parents, but visits were not permitted. I first saw these drawings in 1983 in San Cristóbal, Mexico, at La Galería, a popular restaurant owned by Kiki Suárez and her husband Gabriel, who had initiated a children's art project that would bring a terrible vision to the world's consciousness.

In 1983 the United Nations Commission on Refugees estimated that 25,000 Guatemalan refugees were living in fifty makeshift camps inside the Mexican border. Many more come every day. Even then, over 100,000 Indians had been forced to leave their villages because of the Guatemalan government's massive "scorched earth" policy.

Kiki Suárez [*fig. 56*], originally from Germany, told me the story of the children's art project. "We always had a bad conscience about making a good life in a poor country. We listened to many stories that were told to us by anthropologists, archeologists, and travelers working in, or passing through, this border zone, about the Guatemalan refugees living in such horrible conditions. Finally one day we bought food, put it into our VW van, and went across the border to the nearest refugee camp, La Hamaca. That was in July 1982, and many refugees had been there since February. No one had come to bring them food or anything. They were living in devastating conditions and suffering from malnutrition, hunger and sickness. Many refugees had malaria and they didn't have medicine. We couldn't simply say, 'Now we have gone and brought them some help and we have done our duty.' We wanted to do more."

The Suárezes converted the La Galería office into an information center. The walls are covered with articles and news clippings about current events and the policies of the Guatemalan government; and extensive information-filled folders in Spanish, French, German and English are made available to all interested tourists and visitors.

"I thought it very good to have the Guatemalan children make drawings in order to reach people," Kiki continued. "It is very strong proof of their experiences, even stronger than photography. In October 1982, besides the usual food and medicine, we brought paper, colored pencils and crayons to the teachers at the improvised schools in the camps of La Hamaca and La Sombra. We only asked that the children be allowed to draw what they remembered of their life in Guatemala. We came back two weeks later for the drawings. Not all the children drew massacres, but most of the children from Hamaca had created such scenes because they were originally from the villages of San Mateo and Istantán where most of the people were killed."

These drawings were first displayed in La Galería, and then in New York City; the exhibition later traveled to Latin American solidarity centers throughout the United States. The draw-

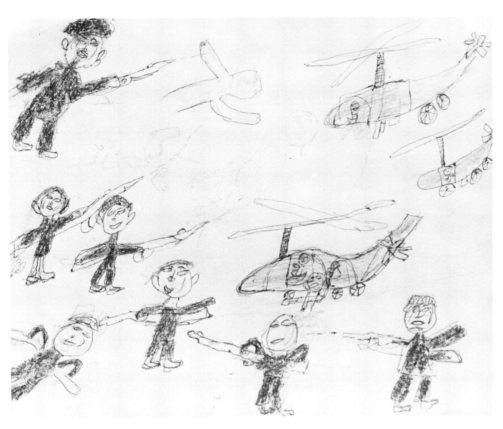

57. Guatemalan refugee child's drawing, signed Francisco (1983).

ings I saw are, like normal elementary-school-age children's work, except for their shocking content, which shows the events that forced survivors to leave their land and homes. Soldiers are outlined with pencil or blue ballpoint pen, the figures filled in with a dark green crayon. Rifles held horizontally almost make the figures seem like a cross, but it is a cross of destruction [*fig. 57*]. Bullets are sprayed at village men, shown with their arms tied in front of them. Helicopters with their pilots are carefully drawn. In Julio's drawing, a rainfall of bullets falls upon peasants in large sombreros who have fled into the tree-covered hills. In two of the drawings wild flames are scrawled across the peasants' huts. In another drawing three soldiers with matches stand by huts [*fig. 58*]. Others are pictured near a woman lying on the ground and a man hanging from a tree.

Soon after their first visit to the refugee camp, Kiki and Gabriel, together with a Canadian church and an American Indian organization, Akwasasne, initiated an outreach group, CARGUA (Relief Committed for Guatemala Refugees). Their goals were to "provide emergency aid to the refugee families, such as food and medicine; help coordinate our activities with other solidarity groups; undertake various kinds of projects for the benefit of the refugees and the Mexican farmers who have sheltered them; and inform the world about the situation by presenting children's drawings and the refugees' testimonies."

With funds contributed from many solidarity groups throughout the United States and Europe, trucks have been purchased, and three Mexican drivers now disperse an average of twenty tons of food per week to thirty camps housing nearly 14,000 people. Two doctors also work with CARGUA.

Kiki told me that materials for loom construction, fiber, and embroidery supplies were also delivered to three of the camps, and once again some of the women have begun to weave *huipiles* and other traditional textiles. However, production is slow as it takes at least three months to create a good quality garment. Smaller items such as embroidered drawstring bags are now available for sale in some of the San Cristóbal stores. Some of the finished products have been collected by CARGUA and sent to the solidarity groups. That these women will be able to continue their traditional weaving is a hopeful development, but it is uncertain how many refugees will survive their ordeal and will be allowed to settle in Mexico.

As Kiki Suárez looks ahead to the future, she hopes to raise more funds, and even more important, to disseminate information. "Many people are far removed from understanding the political realities of the world. People don't start an uprising because somebody puts ideas in their heads. People start an uprising when they are hungry and don't have anything more to lose. As long as governments don't function so that people can live in dignity, there will be revolutions."

58. Guatemalan refugee child's drawing (1983).

TERESITA FORTIN

Although I arrived in Honduras three months too late to meet Teresita Fortin, who died in March, 1982, I was to feel before I left the country that I had actually known her [*fig. 59*]. Teresita's dedication to her art in spite of her family's opposition is a familiar story to many women who have chosen to define themselves through professional commitment rather than through marriage and children. Fortin might have died in poverty and total obscurity, except for an unexpected friendship with Irma Leticia de Oyuela which began when Fortin was over sixty years old, an age not usually thought a time to bring a buried vision to creative fruition. Few artists are so fortunate as to have a perceptive friend and catalyst like Irma to provide direction and encouragement.

I was brought to Irma's New Continent art gallery in Tegucigalpa by Anibal Cruz, a painter and young faculty member of Honduras' National Fine Arts School. Tall narrow gallery walls were filled from floor to ceiling with paintings by young Hondurans. The two small gallery rooms were crammed with bookshelves, plants, an assortment of antiques, and folk art. There were chairs available so that visitors could see the paintings in a comfortable, historical environment or to sit and talk.

Irma and I sipped strong, freshly brewed coffee and talked about Teresita Fortin. Some of her paintings seemed reminiscent of old, intimate family photographs. They were large canvases, three by four feet, and their soft colors were thickly layered and applied with impressionistic brushstrokes. Fortin's oil paintings have a quiet, less demanding presence than those of some of the younger Honduran painters who work with bold color and shape. Although her work stands apart in style and theme, both the woman and her paintings were loved and respected by the younger generation. Two years before her death, Teresita Fortin was selected as the first recipient of a juried national award for painting which had been established by five hundred Honduran artists.

Born in 1896, Teresita was one of several children from a wealthy family. Painting, piano, and literature lessons were provided for the girls as accomplishments helpful in attracting marriage prospects. Her sisters wed wealthy professional men but Teresita wanted to paint instead of getting married. Her father informed her that "all women who paint are prostitutes," and she had to paint in secret. Her mother died when she was very young, and when her father left Honduras to pursue an adventurous life in Paris, Teresita was free to paint. She experimented with watercolor, pastel, and charcoal, doing mostly traditional landscapes and portraits. Under the direction of the artist Alessandro del Vechio she learned to "experience the feeling of volume arrived at so splendidly by the great Italian masters" in the medium of oil paint. Through the 1920s she gave art lessons to children, restored a 17th- century paint-

Painter of Memories
Honduras

59. Teresita Fortin, Honduras (1982).

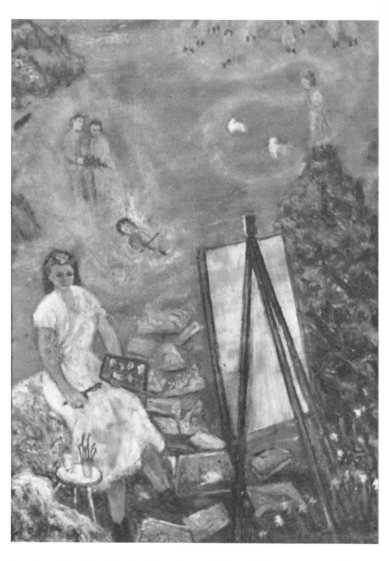

60. Teresita Fortin, *The Story of My Life* (1978). Oil on canvas (detail).

ing in a local cathedral, and participated in twenty collective and individual exhibitions.

The 1930s depression brought her father back from Paris. It also brought three Honduran painters, whose knowledge of cubism, surrealism, and abstract art opened up new horizons for Teresita. Together they founded the first fine arts school in Tegucigalpa.

On returning to Europe in the late 1940s, the three men wanted her to join them so that she could study there. They even arranged a scholarship for her at an art school, but her father would not let her go. "Go to Europe, leave me alone, I don't have anyone but you to take care of me. I will die." So Teresita stayed in Honduras, caring for her father until his death in 1951.

Having lost the opportunity for real training and exhibitions of her work, she was isolated from any community of artists. Irma told me how she had been virtually abandoned by her

family, that her brothers and sisters, "wealthy egotists," did not approve of Teresita the nonconformist. "In Honduras," Irma said, "when a woman reaches thirty or forty years of age and her hair turns gray, it's as though her whole life has ended. She has no more value." Ill and impoverished, she moved to the small town of Valle de los Angeles where she went on painting.

"Teresita always painted with a great passion," Irma told me. "She had no interest in money, nothing more than her work. She gave most of her work away as gifts. She painted as a way of giving thanks to God for each day of her life." In her old age, afflicted with memory loss and spinal meningitis, Fortin was befriended by Irma Leticia de Oyuela, who found a house for her in Tegucigalpa and arranged for a young artist-companion to live with her. Soon, young artists began to visit.

Irma encouraged her to paint her memories and dreams, instead of conventional landscapes. In 1977, Teresita had a one-woman exhibit of twenty works at Irma's gallery: *Recuerdos* (Memories). In the catalog Irma writes: "Teresita Victoria Fortin is an artistic phenomenon of Central America. She is an older person with a delicate and fragile appearance but overwhelms her curious admirers who are surprised and cannot cease to admire her, seeing how she works intensely, possessed by an intense spiritual strength as at age of eighty she presents us with this magnificent exhibit so that we can celebrate her golden wedding with painting." Irma thinks of Teresita's paintings as "naive," as coming from "an internal state of grace."

In her painting, *The Story of My Life* [fig. 60], Teresita pictures herself as a young girl painting, amid symbolic references to real and imaginary events of her past. *Civil War* [fig. 61], painted in 1978, documents a period of Honduran history recalled from her childhood. She stands beside her father and brother in wartime. This scene has been painted in a flurry of suggestive brushstrokes, moving from deeper, more intense colors in the foreground to softer values of greens, blues, and browns in the distance.

In 1978 Fortin was invited to exhibit in Rome at the World Naive Painters' Exhibition. In 1980 she traveled to the United States for an exhibit held in Washington, D.C., commemorating International Women's Year. Teresita's painting, *El Futuro, El Pueblo Feliz (The Future, A Happy People)* [plate 4] was part of this international exhibit of women's art. In November, 1980, Irma organized Fortin's second exhibition of forty paintings, *My Life*. The exhibit space was furnished in 1930s style and records from that period were played. During the twelve intense days of the exhibit, which was open day and night, thousands of people came to see her work. A few months later, while friends held a fiesta around her deathbed, Fortin asked for twenty more stretched canvases, hoping to complete them for another exhibit to be held in September. She died March 5, 1982.

61. Teresita Fortin, *Civil War* (1978).

Fortin helped make art a more acceptable career choice for other Honduran women, and her memory will inspire more than those who knew her. In the words of Irma Leticia de Oyuela: "Teresita was the best woman painter of Honduras, and has made the strongest impression upon me of any painter I have ever known. For me she was a true champion of peace. She should be given the Nobel Peace Prize. But this will never happen. She was not political.... In twenty years people will come to study her. Her work reveals part of the history of Honduras and remains as her testimony of love for all humanity."

With national support of the arts since the 1959 Cuban revolution, there has been a proliferation of artists of both genders and all ethnic heritages. Conditions of life for women, and particularly women artists, have been vastly changed, mostly for the better. In comparison with the United States and other countries, personal freedoms are not as great; full government support imposes well-defined social responsibilities. For some artists, that can be seriously limiting; and it is well known that artists have chosen to leave Cuba. However, the country has an unprecedented number of artists—many of them women—who are well integrated into the socialist structure.

In Havana in 1983, I interviewed three woman artists—Mirta Cerra, Rosa Ana Gutiérrez, and Juana Kessel—and learned of the circumstances that led to their professional and artistic achievements and about their roles in Cuban society. I first met Gutiérrez, a painter and printmaker, by chance at Havana's Experimental Graphic Workshop, and she later introduced me to the painters Cerra and Kessel. All three women live near one another in the crowded section of Old Havana, on streets lined with tall colonial-style buildings with colorful posters decorating walls and doorways. Paints and easels compete with basic necessities for space in their small apartments.

Representing three generations, they work in diverse styles and media; and their art in no way conforms to a single aesthetic concept. They belong to three government-sponsored art organizations: Profesionalizada, Union of Artists and Writers of Cuba, and the Saiz Youth Brigade. Each of them has taken part in many collective exhibitions and has had individual showings of her work. As professional artists, they exhibit and sell their paintings and prints; and the two younger women augment their incomes with a secondary career: art supervision and art restoration.

MIRTA CERRA

Mirta Cerra's long creative life is reflected in paintings that range from social realism to abstraction [*fig. 62*]. A woman of independent spirit, she broke away from the confinement of her early academic training, claiming essential the "maintenance of one's own personality."

The tall beige walls of Cerra's long, narrow, second-floor studio apartment open upon a balcony overlooking a confusion of plants, clotheslines and neighboring apartments. Her recent nonobjective paintings, a series of small canvases composed of cubist, fragmented shapes are inspired by such still life subjects as plates, teapots, and fruit [*fig. 63*]. Displayed upon the apartment walls, they offer a strong contrast to the sculptural forms of her early figurative paintings. Then seventy-eight years old, she said, "If I want to or I don't, I still must pick up the paintbrush."

Professional Diversity
Cuba

62. Mirta Cerra, Cuba (1982).

63. Mirta Cerra, *Still Life* (1982).
Oil on canvas.

Her enthusiasm for painting began early: "As a small child, whenever I found a crayon, pencil or paper, I began to do something, to draw, to make dolls." Born in 1904, Cerra grew up in a small town outside Havana, and won a scholarship in 1934 for study at the National Fine Arts School San Alejandro, which was founded in Havana in 1818, but did not permit women to study there until 1879. The first enrollment of three women—among 303 men—grew to 123 women in 1884. The study of literature as well as art was encouraged for upper class women, though they were expected to marry. Cerra was "stimulated by the companionship of other art students and good teachers," yet she felt that the academic approach to art was "limiting. If you left the academic line, you were not appreciated."

Mirta's travels in Spain, Italy, and France were important to her development, when her European friends helped her arrive at a sense of self-acceptance and let her know that her work was art. In the early 1940s she received another scholarship to the Art Students League in New York where she studied graphics and sculpture. Soon after returning to Cuba, Mirta "realized painting would become my principal means of expression."

Her early canvases were inspired by childhood memories of campesinos, whom she painted in monumental, sculpture-like

forms. These paintings, thirty by forty inches in size, began to evolve into more personal groupings of people as in *Figures* [*fig. 64*] painted in 1954.

Influenced by cubism, her work changed as one can see in her paintings of boats, docks and fishing scenes set in Havana. By 1960 she began her most abstract work, utilizing stones, and surface textures of walls, including stains and collage surfaces. Mirta considers these paintings more liberated than her earlier figurative works. "One arrives at the point of realization that everything is interesting."

After this period she returned to abstractions inspired by the forms of Old Havana's narrow streets, balconies, and windows covered with decorative wrought-iron grillwork, fragmented by the intense light and shadow cast by the sun. Her recent still life abstractions emerged from this series of paintings. They reflect the complete liberty and joy she experiences as she applies paint to canvas. She told me how she believes each artistic style "possesses its own unique characteristics and value. Some people like abstract art, others do not... Realism also has the same basic harmony of composition and abstract movement."

White-haired, thin, and in frail health, she continues to paint "what and how I want." She describes her work as "natural, simple, and not forced. If I don't paint certain days, I think about it. My model is in my mind. One sees an image within, finds it of interest, and from this basis creates the work."

Mirta Cerra is now one of fifteen artists (five are women) categorized by the Cuban government as *profesionalizada* which means that they no longer need to have any other employment and receive a guaranteed government salary in return for a percentage of their art work.

Cerra has received much critical acclaim. She has participated in collective national and international exhibits, as well as having ten personal exhibits. She has also won many prizes and government awards. Besides exhibiting in Havana, her international list of personal shows includes the New School, New York, and the United Nations' Club, Washington, D.C. (1950), and the South America Gallery, New York (1953). Her work is also in the permanent collection of Cuba's National Art Museum.

Mirta Cerra, along with Amelia Peláez (1896-1968), is recognized as a pioneer of modern Cuban art. They are the first generation of women artists to have participated, since the 1930s, in every major exhibit of Cuban art. In 1979, in honor of her seventy-fifth birthday, Mirta was given a major retrospective of her work at the National Art Museum in which over 100 paintings were exhibited. The art critic Leopoldo Romanach wrote of her then: "Mirta Cerra is an artist of extraordinary merit who has maintained the rare condition of conserving her personality in her paintings, which are painted with the experience of an old master."

64. Mirta Cerra, *Figures Composition* (1939). Oil on canvas.

Ana Rosa Gutíerrez

When I first saw Ana Rosa Gutiérrez at the Experimental Graphic Workshop in Old Havana, she was seated on a tall stool at a table cluttered with portfolios of prints, drawing with crayon on a smoothly ground lithographic stone. Several other artists were also at work on wood blocks or etching plates on this hot, humid afternoon.

The Workshop door was wide open. Visitors were welcome to watch the artists and printers and to view the enormous variety of prints on the walls and in portfolios that had been produced by Cuban artists since the founding of the workshop in July, 1962. I was told by the workshop *responsable,* or director, that Gutiérrez had been one of the four founding members of the workshop, which now boasts forty-eight members, of whom eight are women.

When Ana Rosa Gutiérrez and I began to talk, we quickly discovered many shared interests and we then arranged to meet again the following day at her studio, where I could see more of her prints and paintings. *Black Doll, White Doll [fig. 65]* was inspired by José Martí's story about Cuba's mixed African and European cultural heritages.

Her small studio is located on the second floor of an apartment occupied by her parents, where she works at night and on weekends and holidays. An exuberant, energetic woman, Gutiérrez makes prints, watercolors, drawings and oil paintings that are frankly political. Her painting, *Revolutionary Triumph* (1978) *[fig. 66],* illustrates Cuba's postrevolutionary economic progress. Some works are inspired by Cuba's past revolutionary tradition and others grew out of her three month government-sponsored trip to Vietnam, Korea, and Laos in 1980. But Ana Rosa says, "I have more than one way of working. Every time I work, I create however and whatever I want."

Images of people dominate her work. Her linoleum and wood block prints incorporate an interesting balance of solid black shapes that that contrast with cut and textured areas. In one print, a Cuban and a Vietnamese stand together below a ribbon-like slogan held in a dove's beak: Long Live Internationalism, We Are Not Afraid *[fig. 67].* In another the complex design of International Year of the Child is divided into sixteen cubes, each containing an illustration of one or more children playing *[fig. 68].* Born in Havana in 1925, she began, at age fifteen, six years of study at the Escuela Nacional de Bellas Artes. After she married Carmelo Gonzales, a young painter and printmaker, the couple went in 1946 to the United States, where Carmelo studied printmaking on a Cuban government scholarship at New York's Students' League. Ana Rosa recalls that it was too expensive for both to attend school, so she spent most of those years looking, learning and studying. She frequented all of the art museums: "I knew them like the palm of my hand." In 1950, while bringing an exhibit of Cuban

65. Ana Rosa Gutiérrez with *Black Doll, White Doll* (1982). Woodblock print.

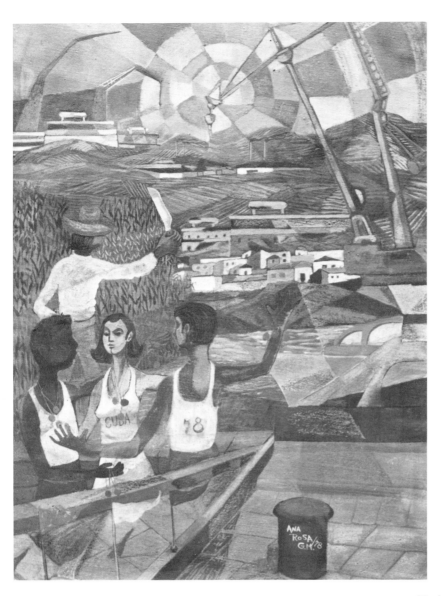

66. Ana Rosa Gutiérrez,
Revolutionary Triumph (1978).
Oil on masonite.

art to Mexico, she worked at Mexico's printmaking workshop, the Taller Gráfico Popular.

Today Gutiérrez is employed by the Ministry of Culture as supervisor of seventy art teachers in fifteen counties. She also organizes weekly workshops and exhibits of teachers' and students' work. Although she finds this work fulfilling, her own painting and graphic work has to "wait until the night," and even some nights are spent arranging art fairs. "But," she claims, "I am satisfied with discovering more artists—the more artists, the better."

Twelve hours of Ana Rosa's forty-four hour work schedule are devoted to a required four hours of studio work and eight hours of theoretical study in subjects such as politics, art history, and the folk art and traditions of Cuba's Afro heritage. Through the

67. Ana Rosa Gutiérrez, *Long Live Internationalism, We Are Not Afraid*. Woodblock print.

68. Ana Rosa Gutiérrez, *International Year of the Child* (1982). Woodblock print.

years she has participated in over 200 collective national and international exhibitions and had twenty-two personal exhibits of her work. She has even earned the Doctorate Degree in Art at the Instituto Superior de Arte. Ana Rosa says, "One never stops learning. When one is finished, it is still possible to continue. There is always something more."

JUANA KESSEL

Since 1975 Juana Kessel has painted *gruas,* or construction cranes [*fig. 69 & plate 5*]. Using thickly applied brush strokes of bright blue, red, and orange oil paints, these cranes appear to be organic rather than made of steel and bolts. In some of her canvases the cranes hover upon the horizon, as if they were distant birds or human forms.

Some Cuban painters use cranes to illustrate Cuba's progress; but, for Juana, cranes have almost become a personal obsession since the accidental death of her brother in 1975 at a construction site. When speaking of her crane paintings to me, however, she said, "women also do construction work; I utilize this subject with pride in our socialist reconstruction," and also indicated that they represented spiritual simplicity and world love.

Juana's construction crane paintings had strong appeal to dock workers at an unusual collective art exhibition held aboard a boat in 1976 at one of Havana's docks. Together they discussed her paintings in this typical project to expose workers to art. (Art workshops are commonly held at job locations, including docks.)

69. Juana Kessel with *Crane* (1982).

Born in 1946, she studied art at the National Fine Arts School San Alejandro from 1963 to 1968. Since 1977, at Havana's large National Art Museum in the Department of Restoration, she and two other technicians have restored deteriorated European and Latin American art work from the museum's enormous collection.

Juana belongs to the Brigada de Jovenes Hermanos Saiz, where at monthly meetings, artists can bring their work for review, discuss future exhibits, mural painting projects and holiday sketching trips to rural areas. The Brigada has also organized group trips to Mexico to visit museums and meet with Mexican artists. Juana told me she plans to apply for membership in the Union of Writers and Artists of Cuba, which has about sixty visual artists as well as dancers, musicians, actors and writers.

In a 1977 solo exhibit coinciding with the celebration of the eighteenth anniversary of the Cuban Revolution, Félix Pita Rodríguez writes in the catalog: "Juana Kessel, with an artist's eye of her time, knows how to see and translate the magical poetry of the construction cranes."

Feminism
Is Not
Our Issue
Cuba

As I explored the world of Cuba's women artists, I learned how the arts had developed there historically and about how things had changed for women. Jorge Rigol states in his 1978 introduction, "Cuban painting," in the book, *The National Museum of Cuba,* "fine art in Cuba was born through the infamous wound of racial discrimination." During the early colonial period art and crafts were "in the exclusive realm of people of color," the African slaves who were originally imported to work on the sugar and tobacco plantations. The educated Spanish male aristocracy preferred literary or other professional careers.

As the Spanish colonial ruling class continued to prosper, there was an increasing demand for portrait, historical, genre, and religious paintings. The 1818 founding of the San Alejandro Academy of Drawing and Painting "rescued the profession of painting from black artisans" since blacks as well as women were excluded from admission. During this period the eyes of the teachers and students were "nailed to Europe" as they imitated the neo-classic styles of France and Italy.

In the late 1800s women were finally admitted to the Academy. Amelia Peláez (1896–1968) was the first woman student to obtain a faculty position. Peláez was also counted among the six women of the vanguard group of eighteen artists who participated in Havana's 1927 New Art Exhibit. These artists incorporated the modern styles of postimpressionism, cubism, fauvism and surrealism in their personal interpretation of the Cuban landscape and people.

In 1937 the Mexican and African-influenced paintings of René Portocarrero, Mariano Rodríguez and Wilfredo Lam were included in Cuba's First Exhibit of Modern Art, as well as those of Amelia Peláez. While works by internationally recognized Cuban artists have been shown in New York's Museum of Modern Art and the Pan American Union in Washington, D.C., before the revolution, as Jorge Rigol points out, "the only real liberty for (most) artists was that they could die of hunger." Otherwise, one had "to submit oneself to the control of minor entrepreneurs or the speculative policies of various art dealers."

The revolution brought many new opportunities in the arts. In addition to the old San Carlos Academy, three new professional art schools were established in Havana, and one in each of Cuba's fourteen provinces. Tuition and all art materials are provided free by the government. Not every graduate is expected to be an exhibiting artist as there are many other jobs in graphic design, book illustration, textile design, and teaching; all graduates are guaranteed art-related jobs.

The women I interviewed, who all teach at the university or professional art school level, told me they are encouraged to continue their individual work too, so their teaching schedules are limited to several half days, that is, from around nine to fifteen hours a week. In Cuba, collective rather than individual exhibits are promoted, both in and outside the country. Al-

though most international exhibits and sales are coordinated by the government's Fondo de Bienes Culturales, artists have the right to sell their work to individuals who come to their studios. They also get commissions to produce paintings and sculpture for hospitals, schools, and public buildings.

Cubans work in a variety of styles: expressionist, realist, abstract. This is an exciting contrast to the limitations imposed upon Soviet artists. Cuba's dependence on the Soviet Union for economic survival appears not to have been extended to these kinds of choices in the arts.

Thirty percent of Cuban women work outside the home, and they are issued cards—PLAN JABA—which give them the privilege of going to the head of the line, or *cola,* to purchase food and other necessities which are rationed to ensure equal availability to all. Cuba's Family Code, which became national law in 1976, stipulates that equal pay be given equal work, that child care and household responsibilities be equally divided between husband and wife, and that women have equal opportunity in education and jobs. There are inexpensive day care centers for children of all working mothers, and all medical care is free for everyone.

It seemed to me that the women artists I met were among Cuba's most privileged, respected, and elite workers. They have decent studios even though there is a housing shortage. I asked Adelaide de Juan, professor of Cuban and Latin American art history at the University of Havana and the author of *Pintura Cubana: Temas y Variaciones,* if there were any books on Cuban women's art. She told me, "Feminism is not our issue." She went on to explain that after having been requested, a few years ago, to write an article on women's art for a Cuban magazine, she realized that "it would be wrong to do so, since Cuban women are among the most liberated women in the world, and to isolate them into the special category designated as 'women artists' would be like putting them into a ghetto." Instead, she devoted a chapter to the image of women in Cuban art, but, unfortunately, almost all of the illustrations she chose were of men's views of women.

Although the law has given women equal opportunity, a very small percentage choose to study art. However, those who do, like the women artists I interviewed in 1982 and 1983, make a success of it.

ANTONIA EIRIZ

It is ironic that Antonia Eiriz, one of Cuba's most respected artists would say, "I never thought about painting or becoming a painter. Some artists need to paint or they will die, as everything they do in life proceeds only after that need is fulfilled, but for me, it wasn't that way.

"I was born in the year of crisis, 1929, in this house, and I will die here," Antonia Eiriz told me. At thirteen, she was

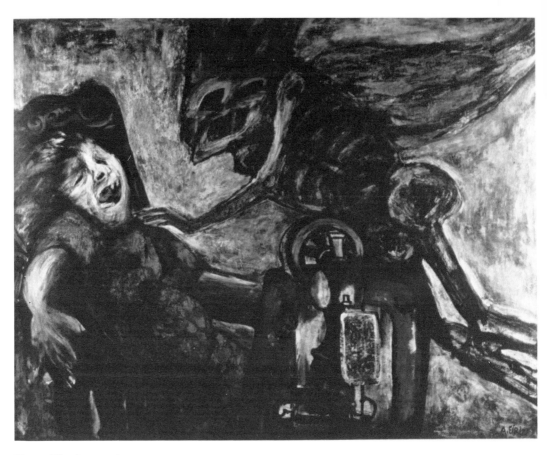

70. Antonia Eiriz, *The Annunciation* (1983). Oil on canvas.

apprenticed to a dress designer, from whom she learned to embroider on a sewing machine. This became her means of support until she finished her art studies at the San Alejandro Art Academy. Her original goal was to learn how to draw so that she could design dresses. She departed from the strictures of clothing design and, after she graduated in 1958, began creating astonishing, explosive paintings.

Her most important mature works were paintings done during a brief but intense five year period. She began in 1963 with a series of carnival paintings, dark in mood, with menacing, teeth-baring horses. Another group of canvases, *Waiting,* depicted the long *colas* in which exasperated shoppers wait to buy rationed goods. In her baseball pictures, such as *Batter,* the faces of the spectators seem mesmerized. The slashing black brush strokes in all of her paintings are reminiscent of the American abstract expressionist painters, Franz Kline and Willem De Kooning, both of whom she admires. Eiriz's colors are mostly deep reds interspersed with scumbled greys and bits of white. The people who inhabit her canvases seem to express an awesome despair, suggesting perhaps a personal view of the early years after the revolution.

Two of Eiriz's large oil paintings, *Annunciation* [*fig. 70*] and *Christ Entering Juanelo,* are displayed in the permanent collec-

tion of Havana's National Art Museum. On dark, somber grounds, vigorous black brush strokes delineate faces and figures in terror and despair. These are a complete departure from other Cuban works of the past or present. The angel in the *Annunciation* is a dark skeletal figure with hollow eyes and gaping mouth; it hovers over a woman seated by a sewing machine and places a bony hand on her shoulder. As the woman receives the angel's news, her face and body express fear, her eyes are closed, her mouth open, and her torso thrust backward upon the chair. It is a black vision.

A large pen and ink drawing, *My Companions* [*fig. 71*], is also at variance with both the still life images preferred by the old cultural elite, and the exemplary models of socialist life expected by the postrevolutionary elite. Nevertheless, Antonia Eiriz has won many prizes for her paintings and she holds a teaching position at the Escuela Nacional de Arte Cubancán. She is Profesionalizada and a member of the Fondo de Bienes Culturales, the committee that selects art to be purchased by the government.

71. Antonia Eiriz, *My Companions* (1958). Mixed media on canvas.

In 1968 Eiriz broke abruptly with the solitary, personal expressions of the easel painter, and never explained why. Now she has come full circle; her interest in art first evolved from her perspective as a dressmaker and once again she is creating clothing, experimenting with batik designs. She has been working as well with papier mâché on a grand scale, having introduced the medium to her classes at Cubancán, and to neighborhood children and their families. She and her students make giant fantasy forms—masks and larger than life-sized puppets—all painted brightly, sometimes collaged with glittering beads, buttons, bits and pieces, and odds and ends of a variety of things, to express the exhilarating spirit of Carnival.

LESBIA VENT

I met Lesbia Vent in the studio she shares with her husband, Carmelo Gonzalez. She and her sister Onedia Dumois studied at the Santa Clara School of Art with Gonzalez. We spoke about his recent paintings, which focus on the sensual curves of the female form; she calls them "surrealist magic." Lesbia uses the human figure too, but in satiric social commentary.

After completing her studies at the University of Santa Clara in 1955, Vent worked for five years as an art teacher in a small town near Santa Clara; in 1961 on a UNESCO-sponsored scholarship she spent six months in Prague, Czechoslovakia, studying lithography. When she returned, she settled in Havana, teaching for two years at the recently formed Escuela Nacional de Arte de Cubancán. In 1965 she became art program director of Casa de las Américas.

Lesbia Vent's imagery suggests to me the English painter Francis Bacon, a comparison she quickly denies. "The solitude of Francis Bacon is not my world; my art has nothing to do with solitariness." She describes her work as a reflection of people's aspirations as well as a satire on people and current events. Vent admits to the influence of Goya and the contemporary American painter of political satire, Jack Levine.

Like many satiric painters, Vent distorts to advantage the facial expressions on the over-large heads of her figures. Her careful drawing is always visible, despite the thickly applied layers of paint.

Some of her strongest subjects are the old bourgeois Cuba. In her 1972 painting, *Forever 40,* the central figure, surrounded

72. Lesbia Vent, *Who is Guarding Whom* (1975). Mixed media on canvas.

73. Lesbia Vent, *Always Fidel* (1973).

by astonished family and friends, is an obviously much older than forty, white-haired woman, pursing her lips to blow out candles on a pink and white frosted cake. In *Who Is Guarding Whom* [*fig. 72*], the large figures of a seated mother, her husband standing behind her, peer from behind a curtain to survey the activities of a younger couple, who seem none too happy by the intrusion. The details of fabric, plants, and flowers suggest a comfortable bourgeois home. Indeed, Vent pays a great deal of attention to the fabric patterns in her paintings. She will often cut a segment of the pattern design in wood, then apply oil paint to the wood surface before stamping the pattern on the canvas surface. This technique offers interesting textural diversity.

Her series *The Dictators* focuses on the political situation in Latin America, and *Truman and the Atomic Bomb, Kennedy and the Bay of Pigs* and *Johnson and the Viet Nam War* satirize American presidents and their policies. These are not surprising targets, but Vent can aim her barbs closer to home. The amusingly titled *Semper Fidel (Always Fidel)* [*fig. 73*], has people sitting around a television set gazing at a huge pontificating Fidel Castro on the screen. As she explains: "Satire is very related to Cubans. We're not clowns, but some of our gestures lend themselves to caricature."

Flora Fong

During the past two years Flora Fong [*fig. 74*] has departed dramatically from her earlier work in oils to create over 100 watercolors that reflect her Chinese heritage. She says her images are derived mostly from books, but also that "perhaps one carries it in the blood."

From Canton, China, Fong's father worked first as an unskilled laborer in Cuba, where he met and married a Cuban woman. Flora Fong was born in the city of Camaguey in 1941. After provincial art school, a scholarship brought Fong to Havana, and in 1966 she began her graduate studies at Cubancán with Antonia Eiriz, "a magnificent teacher and a strong influence." Since graduating in 1970, Fong has been teaching at the San Alejandro Art School.

During her training, Fong took part in Cuba's literacy campaign and harvested crops with other students and faculty members when called upon by the government. She believes that "urban children should learn to plant and harvest even at a young age in order to feel integrated with and develop a love for nature. Since I lived in the city most of my early life, this experience was very important for me...." Her recent watercolors reflect this.

Fong's work between 1973 and 1975 incorporated figurative images; for example, *The Wedding,* in the National Art Museum, and the painting on shaped masonite, *The Couple.*

74. Flora Fong (1983).

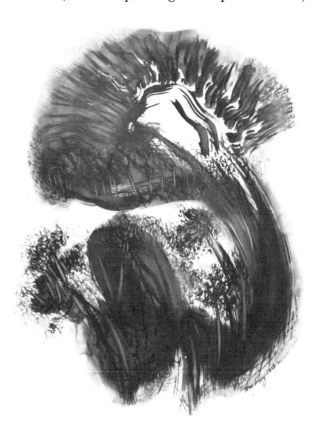

75. Flora Fong, *Cyclone #1* (1983). Drawing, mixed media.

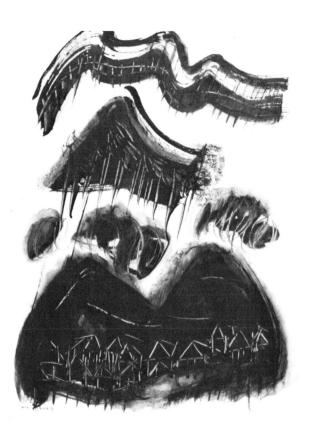

76. Flora Fong, *Cyclone #2* (1983). Drawing, mixed media.

She also blew up common household objects, like the coffee maker in *Extasis de una Colada Criolla,* [*plate 10*], until they filled a forty by sixty inch canvas. The brushwork is loose and expressive, the colors applied to create mood.

Oil paintings of 1983 explore cyclones. Palm trees brushed in with rag become arched slivers of pale blue and white light that stand out against the darker brown and green mountain shapes, which in turn are set against lighter blue and white expanses of sky.

Then came a series of large watercolor paintings of cyclones [*figs. 75, 76*]. At first glance, they appear to be gestures of pure motion and energy suspended in space. However, upon closer examination, marks made with a bambo stick scratched into the wet paint suggest houses, trees, clotheslines, or a wild downpour of rain. The paper's white background makes visible the initial bold gestural application of paint applied either in a single stroke or in several strokes that seem to pull from one to another. With these works Fong broke with her academic, European-influenced training and turned to her Asian heritage.

In 1978 Fong represented Cuba at a Conference of Painters of Socialist Countries held in the Soviet Union. She has also participated in over fifty-eight group shows, and has had four solo exhibits of her work—in Havana, Czechoslovakia, Romania and Angola. Her *Cyclone* series was exhibited in Havana in 1984.

NANCY FRANKO

In a series of recent paintings, Nancy Franko [*fig. 77*] reveals her almost surreal vision of lovers and of childhood. To accompany them, she wrote this poem: "While fish of many colors kiss, there are children who cry in the obscure corners of the world."

Franko was born in Havana in 1951 and very early had a desire to express herself through art. "Since primary school my mother always fought with me because I didn't want to eat, but preferred to paint—although there was nothing in my house to induce art." At fourteen she was sent to the southern mountains to work in the literacy campaign: "The region was very beautiful. I almost didn't want to return to Havana." A love of the natural world evident in her paintings was derived from this experience.

From 1962 to 1966 Franko attended the National Fine Arts School in Cubancán where she met Pedro Rogriguez, whom she married. After their graduation, they were both sent to the Cienfuegos region to help establish and teach at a provincial art school, a two-year assignment that fulfilled their *servicio social* required by the government as payment for their education.

Since 1969 Franko and her husband who share a studio in the crowded colonial Old Havana district have been teaching at the San Alejandro Art School.

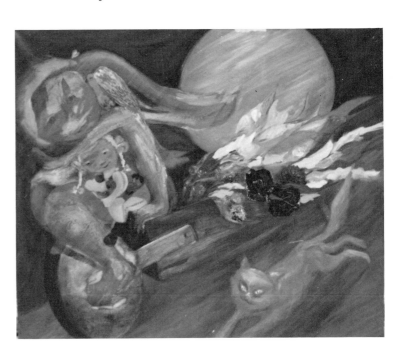

77. Nancy Franko (1983).

78. Nancy Franko, *Coasting Downhill* (1982).

Inspired perhaps by memories of her own childhood or observations of her own two children, Franko frequently paints children at play. In *Coasting Downhill* [*fig. 78*], 1982, she portrays a young girl's joy as she coasts downhill in a small, flower-filled wood cart with a doll on her lap and a parrot on her shoulder. A yellow-orange cat runs alongside and a brilliant orange sun shines upon them. A kind of joyous innocence pervades her work. In *Lovers and a Bird* [*plate 12*], a large bird watches from among tall ferns as a diminutive couple run hand in hand. "The couple have been making love," explains the artist, "and a bird comes along and surprises them, so they get up and leave." Two other paintings in the series depict oblivious lovers embracing: one inside a cactus plant, another inside a typical Old Havana street lamp.

Franko's goal as an artist is "to create images that produce pleasure and make people happy.... "art as well as people shouldn't lose the ability to express the most fundamental emotions of love and beauty."

JULIA VALDES

The hilly city of Santiago with its many white towering cathedrals and winding narrow streets is the subject of Julia Valdes' paintings [*fig. 79*]. In *Santiago Landscape #1* [*plate 6*], she abstracts the city, laying it out like a random patchwork quilt. She begins with an underlayer of bright cadmium red and orange rectangular shapes of pure color, on which are drawn, in black paint, details of the cobblestone streets with their colonial buildings, balconies, flowering plants, clothes lines, and lamp posts. In the background is an intense cobalt blue sky.

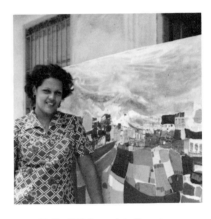

79. Julia Valdes with *Santiago Landscape #1* (1983).

Valdes' paintings capture the essence of Santiago's unique colonial character, with which she is well acquainted, since she was born there in 1952 and, apart from a brief period of study in Havana, has always lived there, in the same house. Her father taught sculpture at Santiago's Art Academy until his death seven years ago. Valdes recalls that "since my early childhood I loved to paint and draw." Her mother had no personal interest in art, but encouraged her studies.

Having an art teacher father proved stimulating, but also difficult because of "the constant comparisons that are made between us, as well as a sense of competitiveness that develops." Father and daughter both began as academic realists and moved to abstraction. The senior Valdes was a sculptor of figures, the younger preferred cityscapes. Another strong influence in Valdes' life was Antonia Eiriz, her teacher at Havana's Cubancán, who encouraged her interest in inner rather than surface realities. Valdes has a wide range of technical skills and can also create controlled architectural or figurative pen and ink drawings.

Since 1975, she has taught at Santiago's Art Academy and is now coordinator for the school's painting program. An advocate of "the government's promotion of public and monumental art within the environment," Valdes has also received numerous painting commissions for Santiago's public buildings and hospitals. She is an articulate supporter of Cuba's socialist structure: "Socialism develops through a series of goals. Since our youth we sense the necessity to participate, to harmonize like a grain of sand in everything we do, including our art work. But," she says, "for an artist, confrontation is necessary and interchange of views. An artist can choose to die or can grow by keeping open."

Valdes is essentially optimistic. Even though she is an active member of the Communist Party, the National Union of Artists and Writers, and her neighborhood Committee in Defense of the Revolution, she claims to have no pressure to relate the style or content of her painting to a more social realist view of life. "According to the Constitution," she says, "Cuban artists are free to paint how and what they want as long as they do not express views that are antagonistic toward the government or the Cuban people.

NOEMI PERERA CLAVERÍA

In Noemi Perera Clavería's monumental sculpture, historical themes reflect the rebellious spirit of indigenous Cubans as well as the African slaves who had been oppressed during the centuries of Spanish rule. These are public sculptures she has been commissioned to make since her graduation from Santiago's Art Academy in 1978.

Her first sculpture, *Hatuey al Mambisa,* represents the first Indian after the Spanish conquest to rebel against the domination: he was eventually caught, castrated, and killed. This statue, cast in bronze, and almost twenty feet high, is destined for Santiago's Museum of the Revolution. "Mambisa," explains Noemi, "is a name given to the rebels by the Spanish and refers to the fact that the rebels fought against them during the years 1868 to 1885 with just their common machetes, implements of agricultural work rather than sophisticated weapons. These rebels were of African descent, reflecting Cuba's early colonial legacy of slaves imported from Africa to work on the sugar plantations." (Cuba's population is now approximately 40 percent black, 60 percent mestizo; but the city of Santiago is nearly 80 percent black.)

In Noemi Perera Clavería's large second work, a group of men on horseback fights against their colonial masters. *Carga al Machete (Machete Charge)* is a more complex piece, with twenty life-size horses and riders. There has been much technical experimentation and innovation by Noemi and her five assistants in the creation of this monument [*fig. 80*]. They

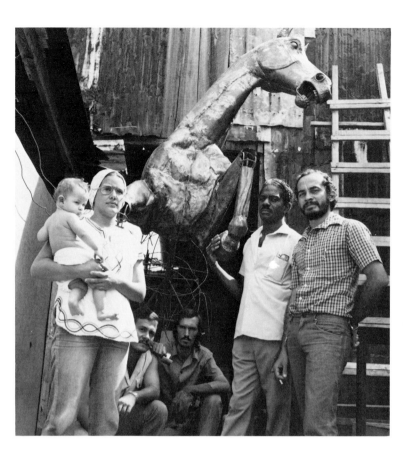

80. Noemi Perera Clavería with her studio assistants (1983).

decided not to use clay as a structural base, but to build the entire piece with a steel framework covered with small sheets of copper. When I was there, five assistants were doing most of the work on *Carga Al Mambisa* while Noemi completed surface textural details on *Hatuey.*

Designs of sculpture for public sites are selected on a competitive basis, first by a regional committee and then given final approval by Havana's National Commission of Monuments. After Noemi's projects were approved, she began work in her studio, which is partly roofless, so that pieces can be hoisted up or down.

When she was younger, Noemi says, "I always enjoyed art but didn't realize the possibilities until later." Her studies began when, at fifteen, she was accepted at the Academy; she was one of five women to graduate in 1978—"the first time that there were so many women." Two women have been accepted at the Superior Institute in Havana for advanced studies and the other three, including Noemi, now teach at the Art Academy. Noemi's husband is also a sculptor; although his work is abstract and nonfigurative, he has also had sculpture commissions for the local children's parks. They studied together at the Art Academy, and now he is one of the full-time paid assistants working on Noemi's commissioned pieces.

Body
and
Spirit
Haiti

81. Market, Port-au-Prince, Haiti (1983).

Contemporary Haitian art has survived and flourished under difficult economic and political conditions to command the admiration of the world. So great was the surrealist poet André Breton's admiration for Haitian art that he wrote, "Haitian painting should revolutionize modern painting; it needs a revolution." In fact, he was not alone among intellectuals to have noted its special brilliance; another was André Malraux, who wrote about how African culture came to a spectacular fruition in the United States in jazz, and in Haiti in art. Selden Rodman believes that "not since the Renaissance in Italy has a school of artists so changed the face of a country." Haitian painting, he says, is nourished by a culture that draws no line between body and spirit. Haiti's soul is revealed in an unfailing capacity for gaiety, artistry and love in the face of adversity.

In economic terms, Haiti is the poorest country in Latin America. Although it became the first Caribbean nation to be free of colonial domination when it threw off French rule in 1804, ever since it has been governed by a series of despotic "presidents-for-life."

The roots of Haitian art are deep in the Voodoo religion, brought from West Africa by blacks in the early 1500s. The philosophical orientation and communal ceremonials of Voodoo helped slaves survive their hopeless ordeal, and later this religion became a means of organizing revolt. Voodoo priests, both men and women, have always decorated Voodoo ritual objects such as *assassons,* or gourds, altars, and vessels with symbolic images. Before each ceremony, the Voodoo priest draws a *vévé,* a linear design on the earth with white flour or ash (held between his fingers), similar in technique but not as elaborate as the sand paintings of Navaho Indian hosteens. The *vévé* will be danced on and eventually destroyed by the ritual participants.

In Port-au-Prince anonymous examples of folk art can be seen on gaily painted homes, shops and tap-taps, a means of public transportation [*fig. 81*]. Painting, that is, transportable images on paper, masonite, and canvas has become a popular art over the last forty years. De Witt Peters, an American conscientious objector, began the famous Centre d'Art in Port-au-Prince when he was sent there by the United States Army in 1943 as an alternative to active service. For the first time in Haiti there was a place to exhibit and promote the work of Haitian artists. Peters also organized Saturday art classes where anyone could come and learn basic painting techniques. This was the origin of the renowned Haitian primitives, so called because the first painters had little or no formal training. Even with the growth of galleries, the Art Center is still the place where most artists begin their training. In contrast to commercial galleries, the Art Center takes only a 30 percent commission on sales, and with spacious facilities, can feature monthly, group shows and one-person exhibits. Several rooms are filled with many different artists' work, taken on a consignment basis.

Since Peters' death in 1957, Francine Murat [*fig. 82*], his former secretary, was appointed the Art Center's director. African art historian Dolores Yonker claims that Murat has by her personal commitment nurtured a whole generation of Haitian artists. She has expanded its program and influence, initiating exhibits by Afro-American artists such as Richard Dempsy, Charles Young, Lois Mailou Jones and Romare Bearden, and has given exhibitions to women artists. In 1973 the first exhibit of women's art, 42 Women Painters of Haiti, was held at the Center in conjunction with International Women's Week. However, very few women are included in books and catalogs of Haitian or naive art, and they have not received the recognition accorded Haitian men artists.

In June, 1983, I interviewed five Haitian women painters: Louisiane Saint Fleurant, Rosemarie Deruisseau, Françoise Jeanne, Vierge Pierre and Mariléne Villedrouin. I was fascinated by their ideas and styles of painting, as well as their personal backgrounds and motives for creating. All are professionals, having painted and exhibited for many years, supporting themselves, at least in part, on sales of their art.

82. Francine Murat, Haitian Art Center Director, Port-au-Prince (1983).

LOUISIANE SAINT FLEURANT

Louisiane Saint Fleurant [*fig. 83*] has held a ladle in her hand much longer than she has a paintbrush. At the age of fourteen she began cooking for other families, and it was not until she was forty-four that Louisiane began to paint. She was born in a small village where her father was an agricultural worker. Louisane still returns there occasionally to do ceramic sculptures [*fig. 84*] and oversee the work on the little land that she has inherited from him. She now lives in Petionville, on a hillside above Port-au-Prince.

When Saint Fleurant got a job as a cook for a painter named Tiga, "he obliged me by giving me a canvas and paint," she told me. Between chores for Tiga's family, she painted and took the lessons Tiga offered to the local peasant artists of the St. Soleil Community.

Rather than teaching technique, Tiga encouraged people to paint their inner visions, which were often inspired by Voodoo. Louisiane told me that though there were other women in St. Soleil who began to paint with her, they don't practice it any more. She paints every day. "Even if I'm sick, I keep painting, and painting helps me feel better." She prefers to paint when she is alone, but this is often not possible as she shares quarters with an extended family. Tourism, a significant source of her sales, has diminished in Haiti in recent years, but the art dealer, Selden Rodman, handles her paintings through his Jacmel Gallery. In the beginning, she says, "my paintings sold for a song," but with the 1960s demand for Haitian primitive art, her work began to command better prices.

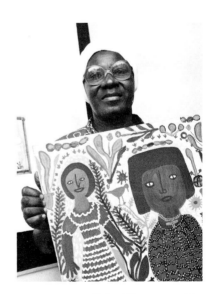

83. Louisiane Saint Fleurant with *Friends* (1983).

84. Louisiane Saint Fleurant,
Untitled ceramic sculpture (1981).

Louisiane's house has two small bedrooms, a front room, and a shop, where she sells beer, soda pop, kerosene, and staples such as rice and beans. Propped up on her easel, which is a chair beside her bed, there is always a painting in progress. Her acrylic paints, brushes and palette are kept on another chair. She usually works on three or four paintings at the same time. In a corner of this eight by ten foot room are shelves on which are stacked almost a hundred completed masonite paintings.

Louisiane first applies a coat of white paint before beginning spontaneous outlines of basic forms. Then she fills them in with a single color, and finally applies contrasting dots or short strokes of color around the principal image to create a vibrating effect. Complex scenes are organized on a single frontal plane without conventional perspective, but by varying the size of her figures, she accommodates a multitude of textures and events.

Her themes are visionary and come from childhood memories of her village life. In *Villages* [*fig. 85*], boys and girls are framed by an irregular tree branch extending across the painting. A woman sits on a traditional Haitian wood-carved chair in the center. Plants, flowers, and birds fill all of the spaces between figures, so that a gay, exuberant feeling is achieved.

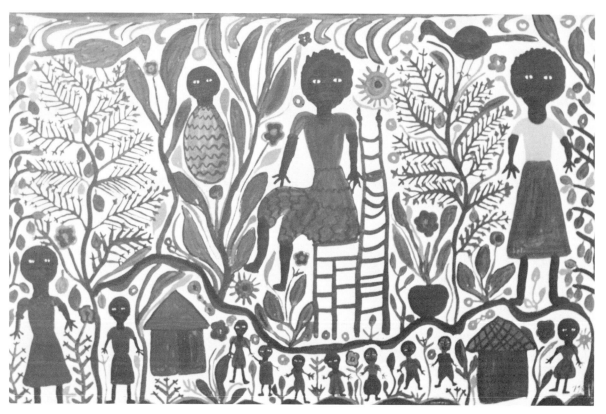

85. Louisiane Saint Fleurant,
Villages (1983).

The Bourgeois Woman in her Garden [*fig. 86*] gives visual excitement with the dark and light effect made by blue, green and red foliage and dark figures. When I asked Louisiane about her *Three Goddesses* [*plate 7*]—dramatic, strong, simple figures radiating light—she told me that these are "powerful women who have no need for arms." Saint Fleurant's warm personality, her optimism and joy of life are reflected in her work. "Painting gives me pleasure," she says, "it is recreating something that is really beautiful, that I see before my eyes."

86. Louisiane Saint Fleurant, *The Bourgeois Woman in Her Garden* (1983).

ROSEMARIE DERUISSEAU

Rosemarie Deruisseau, [*fig. 87*], who told me she has been in love with art since she was a small girl, was, at the age of fifteen, the youngest person to attend the Art Center's classes. Her studies were interrupted by marriage and the birth of her son, and only eleven years later did she enter the Academy of Beaux Arts from which she was the first woman to graduate. She has taught there since 1974.

The full-time study of art is still a luxury in Haiti, and not a possiblity for most talented Haitians even though tuition is only around ten dollars a year. The Academy's total student enrollment is sixty-five, with a faculty of five. The curriculum includes drawing, anatomy, design, art history, water color and oil painting. At the time we spoke, Deruisseau told me she teaches three days a week; in her classes of around twenty-two students there are three women.

Rosemarie said, "I used to paint as much as twelve hours a day, but now I paint less frequently, mostly at night." A woman of independent spirit, Deruisseau decided to remain unaffiliated with any commercial gallery. She has had numerous one-woman exhibits, including one in 1976 at Howard University in Washington, D.C. Her work has brought her so significant a reputation that people come directly to her studio now to purchase her work.

The subject of her paintings is Voodoo. Through extensive research she has become an expert in the meanings underlying Voodoo symbols, body gestures, dances, and use of color. In the early painting, *Trance*, 1970, [*fig. 88*], she uses Cubist fragmentation with brown, blue, and white. The dancer wears the traditional white bandana and dress; her eyes are not focused on us, but seem to be turned inward.

Meditations, [*fig. 89*], also painted in 1970, once again focuses on a single female form, which, though simplified, is more realistically rendered. The figure is seated and we see the entire form of the body composed in a series of gently flowing curves. Her colors are again brown, blue, and white; her emphasis on the face, hands, bell, and candle.

Rosemarie's 1981 *Voodoo Dance,* [*plate 9*], is a complex composition; small details, as well as the gestures of each participant, are clearly painted. This particular Voodoo dance called Yanvalou takes place around the altar or *hounfour,* the red and green central pole. It has a correspondence with the snake, through which the *loa,* or spirit, can enter the devotee's body. The *vévé* has first been drawn on the ground. Some of the dancers are carrying flags and in the background one can see small painted images of the *loas* and ritual objects used in this ceremony. Brown and white are still dominant, but she uses bright colors such as red, green and orange for details.

87. Rosemarie Deruisseau with *Voodoo Dance* (1980).

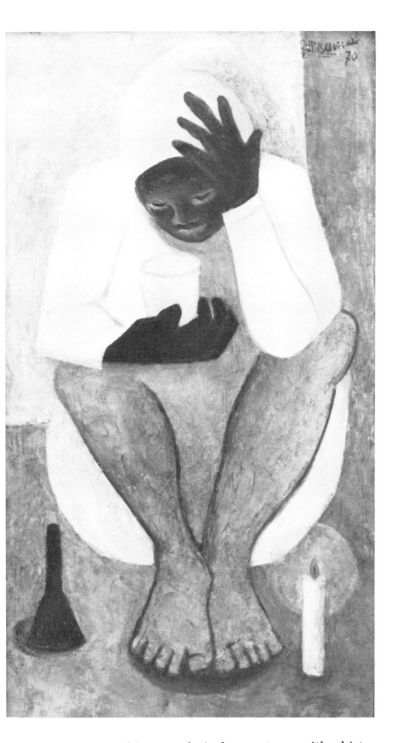

88. Rosemarie Deruisseau, *Trance* (1970).

89. Rosemarie Deruisseau, *Meditation* (1970).

Voodoo Dance combines a technical competency with a historical interest in Voodoo representation. Deruisseau's paintings will provide a valuable documentation of this spiritual tradition for future generations.

VIERGE PIERRE

Vierge Pierre's [*fig. 90*] love of nature was first expressed in decorative embroideries of birds, flowers, and foliage which she created on dresses. She told me that this was how she supported herself when, at age seventeen, she moved with her mother to Port-au-Prince from the small rural town of Petit-Goâve. Her father was a farmer and although her parents were poor, they did the best they could to educate the children, and she was able to attend primary school.

Vierge had what might be considered a late start; she was twenty-six years old before she decided to take painting lessons at the Art Center, where the encouragement of director Francine Murat was very important to her. Only one year later, Pierre's paintings had become so popular that ever since she has been able to sell them almost as soon as they are completed.

90. Vierge Pierre and her daughter (1983).

91. Vierge Pierre, Painted box (1983).

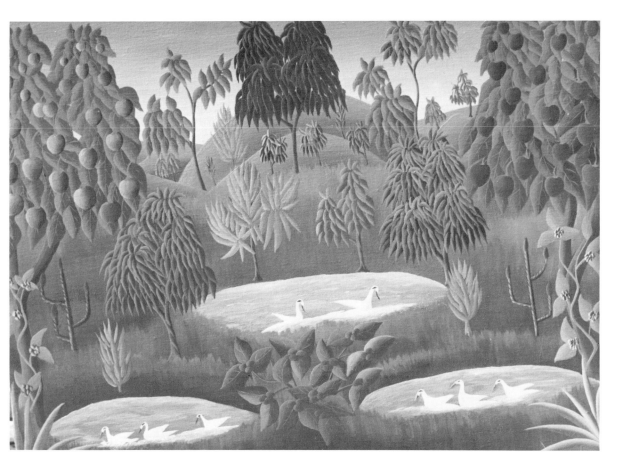

92. Vierge Pierre, *Landscape with Ducks* (1983).

Vierge lives in a small wood frame house with her four children. In her home is a typical black wooden box she has painted with a bold, red flower and green leaf pattern [*fig. 91*], giving an overall effect of lush tropical exuberance. Propped up on a table in the room where we sat and talked, a large canvas showed some lines drifting across the clean white surface, suggesting the beginning of a new landscape.

Vierge told me that when she feels inspired, "it doesn't matter if it is daytime or night, I paint!" It takes her about three months to complete a large canvas. Influenced by the rural landscapes of her youth, she fills her basically symmetrical and static compositions with wondrously detailed flowers, plants, trees, and birds, usually flamingos and ducks. Soft white ducks in groups of two or three glide upon the calm blue water [*fig. 92*], while the graceful pink flamingos stand near the water's edge [*plate 8*]. Blue penetrates the shading of some foliage forms, some of the greens are cool, others blended with a yellow-orange that suggests the reflection of sunlight.

Vierge Pierre's command of color, texture and form is exciting to behold, and the paradisal quality of the magical lands she creates stimulate both the eye and the imagination.

FRANÇOISE JEANNE

Children are the subject of Françoise Jeanne's paintings. Françoise's concentration on the sole theme of children, an appealing one for both the artist and public, has been dictated partially by financial need, and, by her early commercial success. Although she is only thirty, she has been painting professionally for twelve years. From Petionville, where she was born in 1953, she sells her paintings through a large commercial gallery. As a child, Françoise watched her parents create jewelry and do commercial dress embroidery and she spent time with her uncle, a professional painter. Françoise never took art classes but by observing her uncle she was inspired to try to paint. After experimenting for about a year on her own, she began to find a ready market for her work. She paints children at play or at a festive carnival or Mardi Gras [*fig. 93*]. These stylized boys and girls, dressed in brightly patterned clothes, play among grass and flowers under an intense blue-green sky.

In more complex compositions, such as *Mardi Gras,* there are many children wearing costumes and masks. Towering over them is another child on stilts. There are balloons with painted faces flying to meet the soft, rippled clouds above them. Two years ago, one of her larger paintings won first prize in a collective exhibit in Germany for the celebration of International Year of the Child.

Françoise usually paints during the afternoon in the large front room of her house, which is bare of furniture except for a few wooden chairs and an easel. Although she has only one daughter, age six, living with her at home, the voices of her sister's many children at play can be heard from the inner rooms. Her husband, who works full time as a technician in a factory, is also a painter.

93. Françoise Jeanne, *Mardi Gras* (1982). Oil on canvas.

MARILÉNE VILLEDROUIN

Mariléne Villedrouin has always been interested in art, but not until 1976 did she make the decision to paint full time. Recent canvases, of impressive size, have as subject a female figure, symbol of the cycle of birth, growth, and death. The powerful brown women who inhabit these paintings seem equally at ease airborne among clouds or surrounded by the candles of a Voodoo ceremonial. Mariléne's women are never mirror reflections of physical being alone, but, with a multitude of connotations, suggest a cosmic, universal presence.

94. Mariléne Villedrouin, *Illumination* (1983).

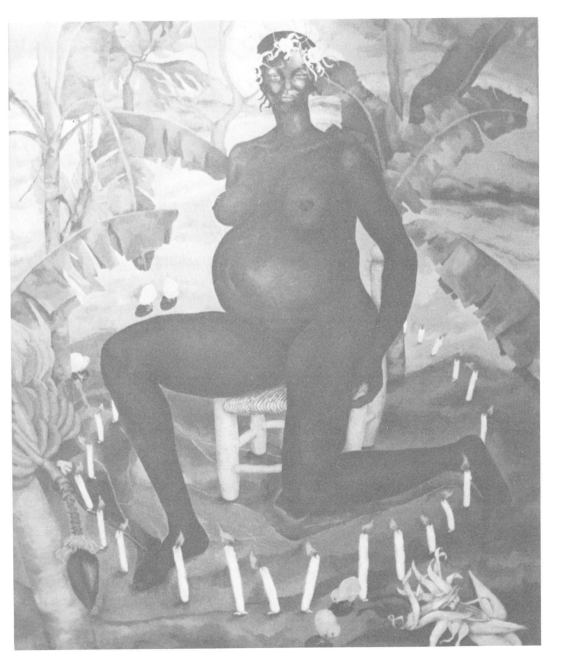

Villedrouin was born in 1950 in Port-au-Prince, where her mother was a still life painter. She majored in anthropology at the University of California at Berkeley from 1972 to 1976, with all of her electives in art. Mariléne told me she was always sure that she wanted art as a part of her life. After returning to Haiti, she married one of Haiti's leading avant garde architects. "The local university did not offer post-graduate courses in anthropology," she said, and so "it was almost as if life forced me into art." Yet in the years that painting has been Mariléne's full-time passion, she has made good use of her knowledge of anthropology, comparative mythology, and the occult.

Before beginning to paint, Mariléne carefully considers the symbolic meaning of her images. In a 1982 painting, *Illumination* [fig. 94], we see the nude form of a pregnant woman seated on a small traditional Haitian chair. Her eyes seem to look beyond us. Twenty-one white candles form a circle around her feet and the color white is repeated in a flower crown on her hair. Mariléne makes a reference to Haiti as "a nation that is awaiting its rebirth. It also symbolizes the pregnancy of nature, the mind as well as the body asking for light, or a spiritual reawakening." Villedrouin is a careful draftsman. With paper and pencil she draws a plan of the entire composition to the scale of the canvas, and when she is satisfied with the accuracy and unity of all the parts, she projects this drawing onto her canvas. Oil paint is her preferred medium, although continuous work from the model is a necesary foundation for the kind of work she does.

Mariléne tells me about *Madonna and Child* [fig. 95]. Erzulie, the Voodoo goddess of love, always dressed in blues, is seated on a Haitian chair as her throne, making a gesture of "a thanks to life." The doves on her head refer to "that moment in a Voodoo ritual when doves are passed over a person's head as an act of cleansing, or to get rid of evil spirits." Parallel symbols are the daisy and the sun, the rooster and child, and the peacock as the goddess Erzulie.

The artist believes that the symbolism in her paintings is common knowledge for most Haitians. In *Celestial Mermaid* [fig. 96], Mariléne was inspired by the divinity of the sea, but, integrating celestial and terrestial elements, she presents her floating in space high above a chain of mountains. A cloud of red roses surrounds her feet and other rose clouds drift below. She explains that she chose to paint brown mountains on the horizon in place of sea coral because their color and sensuously curved shapes are similar to a woman's body. And "the roses are symbolic of warmth, love and perfume, and all the Haitian divinities love perfume."

Preparing for her first major museum exhibit in the United States when we said our goodbyes, she was at work drawing another large mythological canvas, of Baron Samedi, the Voodoo god of death.

95. Mariléne Villedrouin,
Madonna and Child (1983).

96. Mariléne Villedrouin, *Celestial Mermaid* (1983).

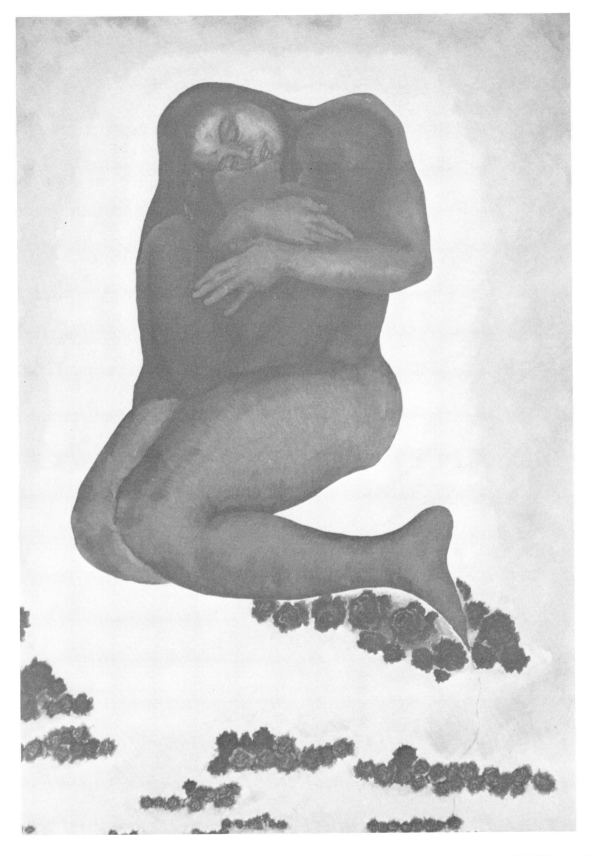

Grencraft
Grenada

Grenada won its independence from colonial rule in 1974, but only after Maurice Bishop came to power in 1979 did the arts begin to reflect a special pride in this tiny nation's black and Carib Indian heritage. It was then that many professionals and intellectuals returned from such countries as the United States, Canada, or England where they had gone to seek education and better opportunities, in order to contribute to the "new Grenada."

Jacob Ross, a director of cultural programs, said, "We are in the process of rewriting our history. It wasn't Columbus who discovered Grenada in 1498, but the Carib Indians who found Columbus standing on their shoes." When these original people of the Caribbean island saw that they faced a future of slavery, they chose death. The site where the last Caribs leapt to their deaths into the ocean is now commemorated in the town of Sauteurs.

Yvonne Palmer, director of Grencraft, a government-sponsored crafts outlet in St. George, told me in 1983 how the role of the arts had changed with people's newly awakened feelings of hope and confidence which were now inspiring new form and content in the media of straw, fiber, and wood—as well as in dance, poetry and music. "Before the revolution," she said, "the craft industry was virtually dormant, and women just took to selling their spices to earn some money. Along with agricultural work, craft producers were the lowest paid." Women who had been creating crafts were isolated and many of the traditional skills, especially in straw weaving, were beginning to vanish altogether. And the few artists who survived directed their efforts to "appeal to the desires of tourists who viewed the 'natives' as an exotic subhuman species vegetating their lives away under the coconut fronds, or dancing and singing in gay abandon to the pulsating beat of calypso and reggae while heavily influenced by the intake of alcohol and marijuana," according to one spokesperson.

In 1981, representatives of the Organization of American States came to Grenada's Handcrafts Center to research the potential of a crafts industry. Subsequently the center's name was changed to Grencraft. While OAS was instrumental in establishing its early program and goals, the organization was to grow with a vision far beyond OAS. By 1983, Grencraft had become the largest retail outlet for exclusively national handcrafts in the Carribean. An inventive variety of straw, fiber, and wood pieces are the main products, although fine home furniture made with native tropical hardwoods and bamboo is sold there too.

When I visited Grencraft and the Grenada National Institute of Handicrafts, I was greeted by a sign that read: "Helping the Hand to Build the Land" [*fig. 97*]. To administer the programs there was a staff of twenty, seventeen of whom were women. With a minimal budget and the use of one small pickup truck, they had organized all aspects of this new crafts industry: gathering and preparing raw materials; training unemployed

97. Grencraft, St. George, Grenada (1983).

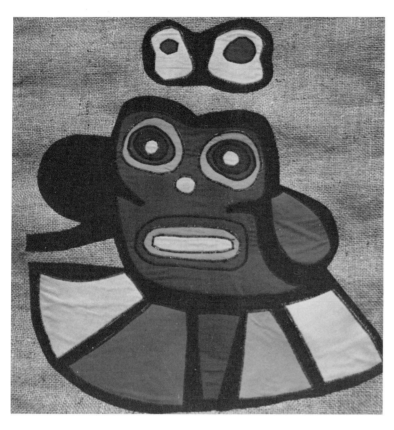

98. Burlap appliqué wall-hanging with Carib motif (1983).

young people and women in all six provinces; providing home employment by transporting raw materials to isolated villages and picking up finished projects; participating in crafts exhibits throughout Latin America; holding art festivals and semiannual design competitions; and design research into petroglyphs and other pre-Columbian, Carib sources [*fig. 98*].

Yvonne Palmer emphasized that most of the 3000 women involved in Grencraft have had no formal art education, and most of them live in rural areas. At first they relied on women like Miriam Samuels [*fig. 99*], trained by United States Peace Corps workers, for design and production methods. But, "more and more we have people coming up with their own designs as they become aware that they have the potential to do it themselves," Palmer said. Much has been done to encourage women to initiate new motifs and forms. Of course, the development of new visual ideas and uses of media in any art is a dynamic process that needs time to mature, and this is especially true in a country under colonial rule for four hundred years.

When Grencraft opened, Miriam Samuels was responsible for creating designs as well as teaching people the skills they needed to make straw and needlework pieces. One of the special crafts she developed is burlap appliqué wall hangings, the designs of which reflect the daily activities of Grenadans— scenes of grinding cocoa, collecting coconuts, carrying water, caring for children, dancing a fisherman's folkdance [*figs. 100, 101*]. In most cases the patterns were first made by Miriam and

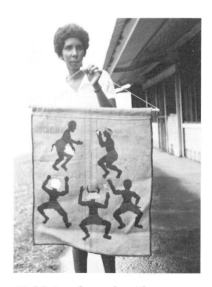

99. Miriam Samuels with *Fisherman's Folk Dance* (1983). Burlap appliqué.

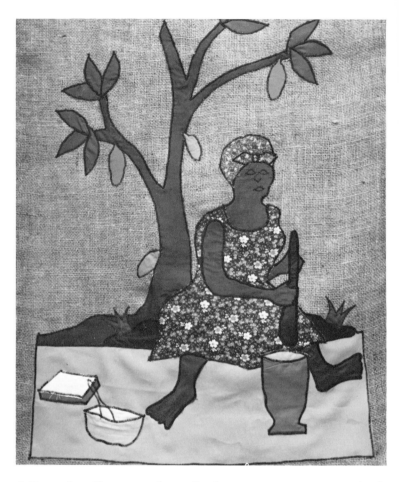

100. Artist unknown, *Grinding Cocoa* (1983). Burlap appliqué.

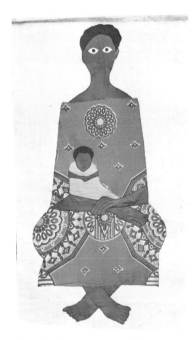

101. Artist unknown, *Mother and Child* (1983). Burlap appliqué.

delivered to "home producers"; since many women are single parents, they appreciate the chance to work at home. They decide what colorful fabric scraps to cut, combine, and stitch by machine to burlap backings. Each image is then outlined by a contrasting border edge, and a wood dowl stick is inserted at the top.

During my stay there, much research, experimentation, and documentation were underway; and Grencraft was producing an enormous variety of straw products such as hats, bags, baskets, table mats, floor rugs, and small items like dolls, slippers, napkin holders, and stationery organizers. Some of the fiber work involved not only unique weaving patterns, but natural color-dye experiments on cotton, silk, sisal, and straw. But whatever the medium, the profusion of crafts was exciting to see. I sensed that here was an example of the personal fusing with the political. As Jacob Ross asserted, "it is extremely difficult to disengage art from the political process, as art is a reflection of oneself, one's reality."

I have not had a chance to visit Grenada again and do not know just how the United States' invasion has affected Grencraft, but I hope it still flourishes, especially the fine beginnings made during the brief revolutionary period to foster artists' pride and initiative and to support their work.

MARGARITA FERNÁNDEZ

When Margarita Fernández brought her family photo album into her studio several years ago, she began to look below the surface images for the meaning of the pictured events and relationships. In an elaborate series of detailed drawings, she started exploring personal and family rites of passage in the context of Puerto Rican society. She sees her work as a way to transmit ideas as well as to better understand herself and her world. "Most artists don't reflect, they are afraid to think!"

Born in San Juan in 1945 in an affluent family, it was taken for granted that she would learn the social graces—to play an instrument, dance, and paint. But by the time she was eleven, she knew she just wanted to draw and paint. Her mother arranged private lessons in watercolor painting, a technique from which she says she learned the value of leaving white spaces for positive object shapes by filling in around them.

From 1967 to 1971 Fernández majored in art at the University of Puerto Rico, where she experimented with the modern nonobjective styles emphasized by teachers trained in the United States: expressionism, minimalism, and conceptual art. Because her training was biased toward pure theory and technique isolated from experience, she "felt a contradiction and negation of my womanness. I was becoming plastic." In those formative years, Fernández told me, she had not yet begun to think about the issues of women's art nor had she developed a consciousness of herself as a Puerto Rican.

After receiving her B.A. in 1971, she joined the humanities faculty at the University of Puerto Rico in Payamón, a small town near San Juan. In 1972, she studied in Mexico City, and then, on a University of Puerto Rico scholarship, she earned her M.A. at New York University. Back home, she began teaching at the university and working as a writer and editor for the Puerto Rican art magazine, *Plástica*.

It was in Mexico that Fernández "made the decision to break with the teachers who had formed me, and to reclaim the figure for myself and my art." With the figure, Fernández was to illuminate the social world of the Puerto Rican upper middle class with a curious combination of charm and mordant wit. "I'm not judging people," she explained, "I'm simply stating this is how we are, and these are our contradictions." Her friends say she works very close to the edge; certainly her satiric view of the family, and of woman's role, opens up an examination of bourgeois values not likely to appeal to commercial galleries. She says, "my art has to be very mature to get there with success. I made a decision not to use high contrast tones or color, because I don't think it would work as well." Her subtle drawings have proved to be a perfect medium for social critique. "Woman's world is filled with many, many tiny details that are all connected. The span of greys that I use is very important to the content of my work, because you have to wait until the work bites you. My work doesn't bite rapidly.

Women–
Little Girls
Puerto Rico

102. Margarita Fernández,
Spanish Lady, (1982–83). Pencil
on paper.

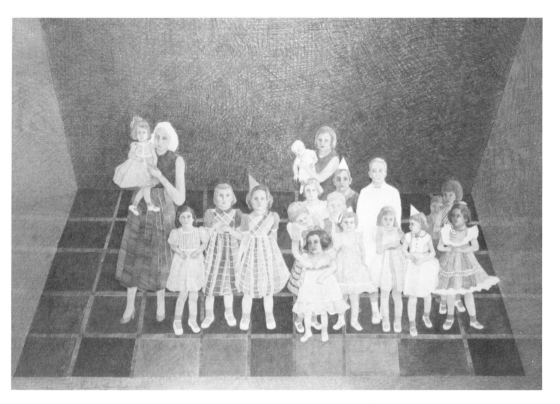

104. Margarita Fernández, *The Birthday Party* (1982-83). Pencil on paper.

It takes time. If you give me five minutes, you are trapped. If I utilized high contrast, the impact is too swift, the people would leave immediately."

Her drawings are made on white Arches paper with soft grey pencils. "Pencil," she says, "is the most humble of all instruments. As soon as artists mature, they usually switch to other media. Pencil is not considered a serious worthwhile instrument of art." Each drawing takes between thirty and one hundred hours to complete. When she begins a drawing, "I'm not sure where it will take me," but as she works, "the meaning becomes clearer. Sometimes as people see my drawings, they reveal to me some of the subconscious meaning of my images."

Her series of around seventy family album drawings was the starting point of a new introspection, a sharply-focused view of the stifling aspects of bourgeois women's lives. These women, she says, "are well-educated and possess the material trappings of life. They are raised to have good manners and not to get dirty, that is, not to do physical work, but nonetheless they suffer in silence, in the isolated enclosure of the home. All the world thinks that bourgeois women are privileged, but this is not what I know." In some ways, she feels, working class women have compensatory advantages. "Working class women suffer visibly, but at least they can work outside their homes to survive, to support their children. They do not live in a cage, isolated from the world." Fernández feels fortunate in her own personal situation. Her husband, a lawyer recently appointed a judge, supports her work and helps with the children. They

103. Margarita Fernández, *The Pregnant Bride* (1982). Pencil on paper.

105. Margarita Fernández, *The Dream State* (1982-83). Pencil on paper.

106. Margarita Fernández, *Self Portrait* (1983). Pencil on paper.

also have outside help. She teaches, but has Tuesdays and Thursdays to work on her drawings in a small studio apart from the house, "where no one comes, no one interrupts, no one tells me what to do."

Her choice of subject was influenced by a feminist support group of professional women she joined about ten years ago. Re-formed in 1983 as Women Artists of Puerto Rico, it gave her "the ultimate support... to affirm myself." And so, like many feminist artists, she drew on her own personal experience to make an art that would communicate a personal and social statement.

In *Spanish Lady* [*fig. 102*], a little girl posing in a flamenco dancer's costume represents woman's place as a decorative being. "We are always on that little cloud. We are living a fantasy." The flowers on the wall suggest the endless hours of domestic craft work women are trained to do in order to enrich the home during holiday and family celebrations. However, society gives no real value or esteem to women's crafts.

In her *Desposados (Newlyweds)* series, *The Pregnant Bride* [*fig. 103*] wears a white gown, rendered like a fish net, its rhythmic mesh encircling the bride's transparent body. The groom, who stands at her side, is overshadowed by her white veil. Fernández uses the fish net pattern repeatedly in women's clothing; the wearers seem caught and trapped in these garments which can also engulf their male companions. She says, "Some of the men who view my work identify with it, and they often realize 'I didn't know *women* felt this way!' Preconceptions about feminism have very often led men to consider it as something funny, not serious."

In *Birthday Party* [*fig. 104*], from the 1982-83 *Mujeres-Niñas (Women-Little Girl)* series, we see a group of celebrants lined up for a group photo. Two mothers, displaying their youngest children, tower above the little girls who look like obedient stuffed dolls in their white patent leather shoes and ruffled dresses. *Dream State* [*fig. 105*], a nonsymmetrical composition, shows the profile of a young bride staring into a small oval-shaped mirror as she applies lipstick. A child's face stares back at her; above the frame is a little carved lizard, a common symbol of fertility. In *Self-Portait* [*fig. 106*], the little girl Margarita seated primly behind a table wears an adult face; this is another drawing revealing the infantilization of women.

In the catalog of her *Mujeres-Niñas* exhibition, the art critic Teresa Tío wrote: "Like Pandora, Fernández opens the box to let the secrets escape. Contrary to this mythical woman, Fernández doesn't liberate the world from evil, but reveals instead many of those evils which claim women as their victims."

During the past two years, Fernández's drawings have received prizes and much critical acclaim in Puerto Rico. She has had individual shows of her work at prestigious museums, and now her drawings are travelling with international exhibitions to Cuba and Venezuela.

The annual transformation of ordinary bread dough into skulls, skeletons, the Virgin Mary, or horses with riders represents a merger of Catholic and Indian traditions. Each November, on El Día de los Muertos (The Day of the Dead), these figures are taken—with a locally produced liquor, such as chicha, mescal or rum—to grave sites. There to honor the dead, people share food and drink with friends, relatives, and official mourners who have all come to offer their respects.

Nearly fifty years ago, Margarita Reza [*fig. 107*], who lives in the small town of Calderón, was no longer content to wait for the annual celebration to create the shaped bread. Ever since she was a young girl she thought that "the spirit of the living needed to be nourished by developing a feast for the eyes, not just for the stomach." And so, thinking that there should be an art to adorn the home throughout the year, she began to experiment with new ideas for making bread sculpture more decorative, visually appealing, and nonperishable. She began to create "whatever I saw in my imagination," such as "big crosses, big red devils with long capes, and little children." She formed the children like elongated shells, set them into a hollow bread ring so they could stand upright, and then textured the outer edge of the support ring with a comb.

Soon Margarita began to invent *masa pan* figures based on everything she saw and experienced. Inspired by the customs of Ecuador's numerous indigenous peoples from Otavalo, Ambato, Saquisili, Riobamba and Latacunga, she developed elaborate male and female figures in the authentic dress of Ecuador's tropical lowlands and the colder mountain regions. They range from four to ten inches in height and with little feet can stand upright when leaned against a vertical surface. However, they are meant to be displayed on a wall, and to do this a looped string has been added to the back side [*fig. 108*].

Bread as Art
Ecuador

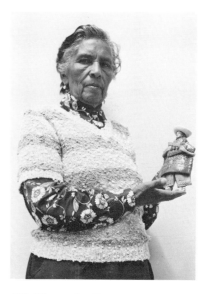

107. Margarita Reza, Calderon, Ecuador (1984).

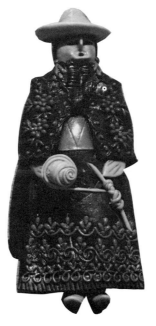

108. Margarita Reza, *Indigenous Couple* (1984). *Masa pan.*

109. Margarita Reza, *Llama* (1984). *Masa pan.*

Fascinated by traditional hand-woven and embroidered garments, Margarita duplicated the intricate decorative patterns of *huicholes, serapes,* skirts and pants, with thin coils of varied, bright-colored dough. She even included distinctive hats and jewelry. The hands of her bread dolls hold a spindle with wool, a lamb, a chicken, or a musical instrument. Faces are three-dimensional, with prominent noses and chins.

Another popular bread figure is the llama, provider of wool for weaving the traditional garments, and knitting sweaters. However, as a bread form, the brown, shaggy-haired llama is colorfully transformed, with long necklaces of flowers and a blanket over his back, patterned with detailed ornaments of carefully shaped petal and leaf [*fig. 109*].

Although Margarita Reza married at fifteen, and soon had four children, she still continued to make, display and sell her colorful art. As demand increased, her husband began to help with the baking of the figures. Before long, a doctor friend and artists in Quito discovered Reza's *masa pan* art. After they brought her work to the attention of the Cultural Ministry, which then displayed them, other shops in Quito began to exhibit and sell her work.

Reza told me that in 1964 she was asked by the Ambassador from Spain to produce several sets of traditional nativity scenes as special gifts for him to take back to Spain. Soon there were many other major commissions, and eventually this modest family enterprise expanded to include from fifteen to twenty workers. Although expanded production meant that there had to be repetition of certain forms and designs, Margarita maintains a personal or individualized approach to the decorative aspect of each piece.

Since Reza shared her techniques with others, her success was soon emulated. Within the last twenty years the *masa pan* industry has converted the small agricultural town of Calderón into an important national crafts center. Wholesale dealers come to Calderón from the United States and Europe to buy

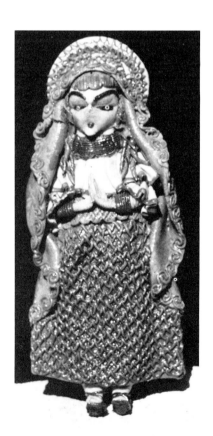

110. Elsa Súarez, *Virgin Mary* (1980). *Masa pan.*

for world export. While some *masa pan* workshops are now totally dedicated to mass production, individual artisans, like Elsa Suárez, still create figures that have individual details, such as a horse with two riders, and a Virgin Mary. These unusual bread figures are time-consuming to produce, difficult to transport, and more expensive, but worth the trouble and expense for the integrity of work. The Virgin Mary's earth-brown skirt, made to resemble woven homespun cloth, shows remarkable technical skill, and Elsa's use of softer natural colors is almost unique at a time when intense pigments are now commonly used [*fig. 110*].

Reza's original bread formula consisted of finely sifted white flour, salt, leavening and water. The figures required four days to dry and for the yeast to act before they were baked half an hour in an intensely heated, outdoor adobe bread oven. Then, transparent varnish was applied to the surface to preserve them, as well as to give all the colors a brilliant luster. Instead of the food color dyes first used, the *masa pan* workshops employ a wider spectrum of synthetic dyes.

With time, came many technical innovations. Certain glues were added, and not all of the figurines were baked. Some were made by applying or gluing innumerable textured dough segments to the surface of light-weight balsa wood. These thin balsa boards were first cut with a saber saw into basic popular forms of fish, owls, roosters, chickens, parrots, peacocks and llamas. The tiny individual dough segments were sometimes textured with a comb before being glued upon the board in overlapping layers to simulate the surface of fish scales, bird plumage or llama wool. Colors were coordinated for maximum contrast, and distinctive features such as eyes, claws, and beaks were carefully integrated into the overall design. However, since quantity is important, each worker must decorate and complete six or seven dozen of the same form in a week before changing designs.

Some workshops cater to foreign tastes by mass-producing Santa Clauses, snowmen and Halloween witches [*fig. 111*]. Flowers are popular everywhere, and can be used as Christmas tree ornaments, decorations for mirror frames, picture frames and boxes, jewelry, etc.

For centuries, Ecuador has had cottage industries employing women who painstakingly sew and embellish cloth for every-day clothing, tablecloths, pillow cases and wall hangings. Many embroideries are also made for export, and one can see parallels between cloth decoration and *masa pan* in motifs and colors [*fig. 112*]. Birds and flowers decorate the tablecloths and blouses made by Mercedes Matute Marin, and Carmelina Sevilla adds sequins to the flower embroideries that decorate the edge of a skirt worn by many Indian women. These women have remained anonymous, while many of the *masa pan* artists sign their pieces. In any case, *masa pan* has become a striking means for visually preserving a record of Ecuadorean life as well as fashioning beautiful home decorations.

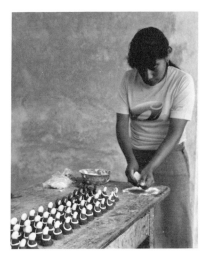

111. Masa Pan Workshop, Calderon, Ecuador (1984).

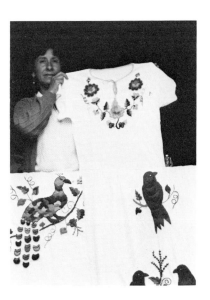

112. Cloth embroidery, Ecuador (1984).

Pachamama and Weaving
Bolivia

113. Linares Street stall, La Paz, Bolivia (1984).

114. Llama fetuses, La Paz, Bolivia (1984).

In Bolivia's capital, La Paz, by a mere turn of one's head one can look up at steel skyscrapers sandwiched between colonial plazas and cathedrals, or look down into a Linares Street merchant's stall at an amazing display of magical herbs, amulets, and llama fetuses [*fig. 113*]. These ritual objects belong to a Bolivia that transcends time, and they seem to lead back to the womb of Pachamama, the spirit of mother earth.

Both the engineer of the modern skyscraper and the campesino will buy these llama fetuses, forlorn vestiges of life's beginnings, piled in baskets and cardboard cartons [*fig. 114*], (llamas abort naturally in severe altiplano winters). The market woman explained to me, "Respect must be given to Pachamama by anyone who builds so that his house won't fall down, so that there shall be no accidents, and that the general well-being of the people will be protected." After the burial of the fetuses and other amulets in a building's foundation, chicha, an alcoholic beverage, is drunk, coca leaves chewed, candles lit, and incense burned. A *curandero* presides over the ceremonies.

Llamas have always been essential to the Aymara and Quechua peoples of the altiplano for food, clothing, and transport. Along with the vicuña and the alpaca, llama wool is the raw material for Bolivia's highest art—textiles. Over 3000 years old, this pre-Columbian art had reached technical perfection by the 1st century B.C. In the Inca empire, cloth was of supreme importance; it even had its own deity, Aksumama, to whom sacrifices of fine textiles were made. For a whole class of gifted women, weaving was a profession akin to a priesthood. When the Spanish conquistadores came, they were utterly overwhelmed by the beauty and magnificence of Bolivian Indian textiles. Before long, they prohibited Indians from wearing luxurious clothing; and in 1780, after an unsuccessful uprising against the colonizers, native Andeans were made to adopt the crude costume of the Spanish peasant. Bolivian Indians today wear a combination of Spanish and Andean regional dress. Most men, still under pressure to buy and wear city clothes, do not wear traditional garments for everyday use.

But many traditions were kept alive in the highlands, and today in rural areas cloth still plays a major role in people's lives. Special textiles are used in ceremonials that reflect the interdependence of agriculture, women, and weaving. Before plowing can begin, a woman makes an offering to Pachamama in her field. Seeds for planting are blessed on a special weaving spread on the ground in the house yard. Frankincense is burned so that the smoke can drift over the seeds. Special pieces of cloth are used for rituals that commemorate birth, puberty, marriage, and death.

In recent years, natural disasters, mechanized agriculture, and an intensive use of fertilizers and pesticides are factors that have forced people from the country into *zonas marginales* at the edge of cities, crowded makeshift districts without water and electricity. As impoverished Indians come to La Paz to

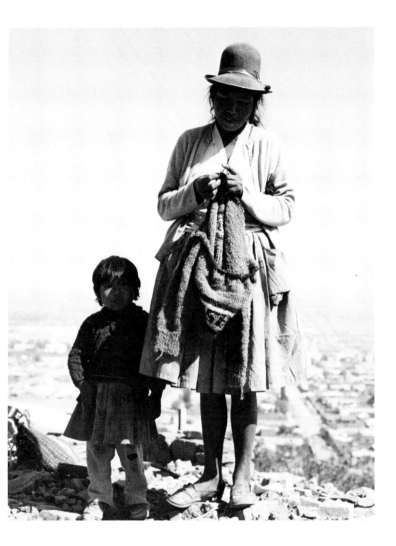

115. Woman knitting a *chullu*,
Cochabamba (1984).

seek cash employment, they must frequently sell their most
prized possessions, among them special ceremonial weavings
that are family heirlooms.

Unemployment is high, and some women provide a family's
needs by a simpler craft—knitting [*fig. 115*]. They work at
home, producing *ch'uspas* (bags), *chollos* (traditional men's caps
with ear flaps), and *chullus* (sweaters), popular with middle
class Bolivians and exported internationally. Ironically, most
women who knit *chullus* cannot afford to wear them, and must
use factory-made acrylic sweaters. At the communal water
spigot in Cochabamba, I saw young girls of eight and nine
spinning wool and knitting expertly with the women, who
carry their work with them everywhere they go [*fig. 116*].

I found it impressive that these women have been able to
adapt skills learned in rural agricultural communities to a
new urban environment. In the *artesania* section of the market,
two unusual *ch'uspas* attracted my attention. One, with an
intricate, geometric black and white design had small decora-
tive flap pockets which, when lifted, revealed an image of

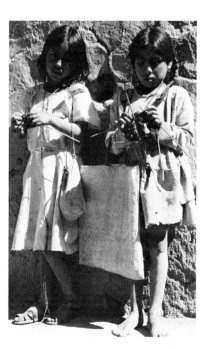

116. Young girls knitting,
Cochabamba (1984).

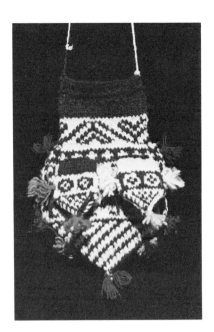

117. *Ch'uspa*, Bolivia (1984).

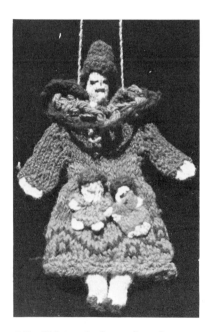

118. *Ch'uspa* in form of mother and children (1984).

119. Finely woven *ch'uspa* for carrying coca leaves (1982).

children holding hands [*fig. 117*]. Another portrayed a traditional Indian woman with bowler hat and a long full skirt, children clinging to her sides [*fig. 118*]. This novel container came in a great assortment of bright colors and sizes. A market woman told me that these *ch'uspas* have been made for only the past five years, and that they could be worn suspended from a vendor's belt to hold money—clearly an innovation for city people.

Historically, finely-woven, small *ch'uspas* have been used by men to carry coca leaves which they chew while working in the fields or tin mines [*fig. 119*]. One small flap-pocket, integrated into the design, holds calcium or lime, the catalyst necessary to activate the coca enzymes. Coca gives relief from cold, helps one endure long hours of toil; it also dulls hunger and provides a temporary sense of well-being.

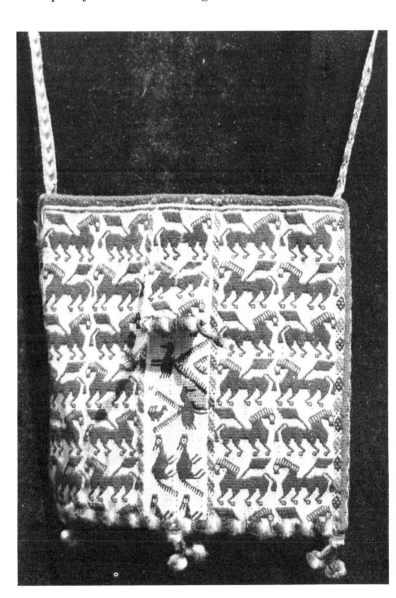

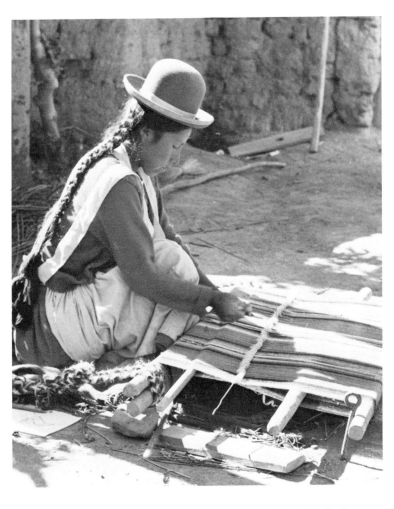

120. Juanita Esteban weaving on a heddle loom (1984).

Although I didn't have enough time in La Paz, I left the city hoping to see examples of traditional weaving. In the highlands there are several important weaving centers; Charazani, famed for the complex symbolism of its ceremonial garb; Pacajes which excels in alpaca work; Bolívar, with its wonderful matrimonial garments, woven with *intis* (sun symbols), cows, and condors; Calamarca, which specializes in human, bird, and animal forms; Tarabuco, famed for elegantly stylized cloths. Laurie Adelson and Bruce Takami report in *Weaving Traditions of Highland Bolivia* that in Potosí the phantasmal animal and bird images are so spontaneous and marvelous that it is said that when women come of weaving age they go to a certain cave to spend the night making love with the devil who inspires them.

After crossing Lake Titicaca in a motor boat, I stopped at one of the smaller islands and entered the Estaban family's small shop. Paulino Estaban had built the totoro reed balsas used by the Norwegian Thor Heyerdahl in his much-publicized Kon Tiki ocean-crossing. Less publicized, but quite as remarkable were *llicllas* and *awayos* woven by the six daughters of the family. The heddle loom [*fig. 120*], developed thousands of years

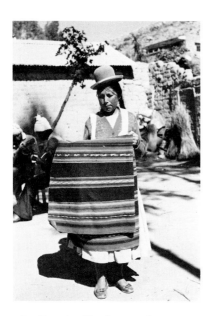

121. Juanita Esteban with carrying-cloth (1984).

122. Bag woven on heddle loom (1984).

ago and still in use, was staked horizontally on the ground of the courtyard. Weaving goes on here in the midst of many activities, from playing the guitar to husking corn. Piled high on the table was an array of woven earth-colored carrying cloths. One of the girls, Juanita, explained to me that "by the time most girls are five or six years old, they learn the fundamentals of weaving from their mothers, and by the age of twelve, they also can produce weavings for sale [*fig. 121*]. It takes approximately eight hours to spin the wool and four days to weave one shoulder bag [*fig. 122*]. The sale of weavings is usually the only source of cash income for families here."

Modernization has reached even the most remote and inaccessible areas of Bolivia. Many aspects of the ancient art of weaving have been lost forever. Industrial wool is sometimes used, and synthetic dyes have in most cases replaced the natural dyes. These were made by women with sophisticated chemical knowledge from cactus, insects, fruits, seeds, leaves, roots, lime, and urine. Gone are the days when textiles were spun so fine the weave could not be seen with the naked eye. Once intricate symbols of the cosmic order and the people's social relationships within it were woven into cloth. Now all that is fading as Indians forget the meaning of the symbols they once wove. Even so, women still play a powerful role in Bolivian culture, and as I came to know them I felt they were true guardians of Pachamama.

A Tapajo votive lamp made of intertwined frogs, snakes, and open alligator jaws supporting little dogs and birds that form phantasmic multiple images, all balanced on a mask base, is one of the exuberant works made and signed by Ines Cardosa [*fig. 123*]. She is one of a few Icoraci artisans of northeastern Brazil who specialize in this fabled Tapajo pottery.

In the 1950s, Brazilian and American archaeologists uncovered ancient ceremonial ceramic pieces produced by the Tapajo, Konduri and Marajo tribal peoples prior to Portuguese colonialization in 1625. (The Tapajo and Konduri are located on the Amazon about 150 miles from the port city of Belém; the Marajo are from Marajo Island at the river's mouth.) Many splendid examples of this work are on display in Belém's Goeldi Museum and in the National Museum in Rio de Janeiro.

Ines and Raimundo Cardosa, who live in Icoraci, a small town near Belém, had the opportunity in the early 1960s to see this pottery. Inspired by the great beauty of these clay figures, the Cardosas decided to start a ceramic workshop in order to reproduce this ancient Indian art, a high achievement from their own heritage [*fig. 124*]. They photographed the original work on display which was helpful in developing pottery shapes

The Revival of Amazon Indian Pottery
Brazil

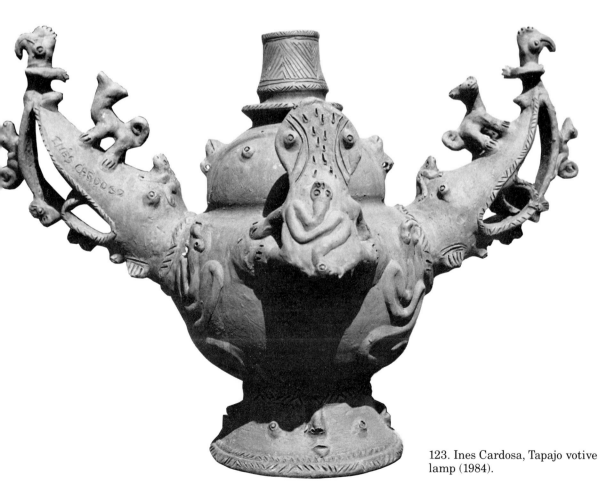

123. Ines Cardosa, Tapajo votive lamp (1984).

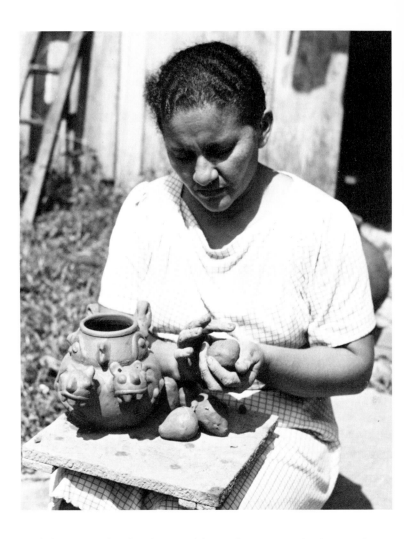

124. Ines Cardosa making
ceremonial bowl (1984).

and designs. The Cardosas told me that no one had been doing
this type of ceramics; it was apparently a lost art. Soon after
initial experiments, they began to sell their work, but slowly
at first, for few travellers came to Icoraci.

Since 1968, over a hundred Icoraci artisans, inspired by the
Cardosas, have become involved in full-time production, pri-
marily of the geometric-patterned ceramics of the Konduri and
Marajo. Since 1980 the Cardosas have had opportunities to
exhibit their work in Rio de Janeiro and other large cities in
Brazil, as well as in Germany and in the United States. In
October and November of 1983, they took part in an Interna-
tional Art Fair in Los Angeles, which was attended by one
million people.

Government support of tourism and of the artisans has also
helped. Paratur, a large government culture and exhibition
center in Belém, features many Amazon Indian crafts: fiber
and feather work, wood carving, basketry, jewelry, contempor-
ary furniture, as well as ceramics. Since its inception in 1975,
Paratur has grown to represent approximately 800 regional
artists, nationally and internationally.

The Cardosas have a unique working relationship, nurtured by mutual support and respect. Their small comfortable home is now dwarfed by an enormous workshop that consists of a series of connecting sheds, about seventy by twenty-four feet. They employ six or seven young people who prepare clay or form basic shapes on the wheel. The intricate geometric designs are made by painting the white pottery surface with a contrasting red clay paint or slip, meticulously polishing the surface with a smooth river stone, and finally incising the design pattern on the outer form, revealing the under layer of color. It takes over a month from start to completion of one large piece of pottery, though each person works on numerous pieces during that time.

125. Ines Cardosa, Tapajo ceremonial bowl (1984).

The atmosphere in the Cardosa workshop is relaxed. At one end, a large wood-fired kiln is in constant use. After firing, each piece is removed from the kiln, then given a bath with cold water and wiped with a soft rag, which removes dust and restores surface brilliance. Work begins at eight in the morning, and at noon Ines calls them all into the house where she has prepared rice and beans for family and assistants. At one, everyone returns to work until five. As owners of an expanding business, the Cardosas' own work schedule extends well beyond eight hours.

The two basic forms of Tapajo pottery that Ines makes are: *vasos de cariatides,* vases that have sculptural clay figures added to the outer forms, and *vasos de gárgola* which are dominated by part-animal, part-human faces [*fig. 125*]. The anthropologists suggest that these Tapajo vases were formerly used as containers for special beverages during ceremonial occasions, such as victory celebrations after war. Ines makes these complex figure and animal shapes with practiced ease.

Raimundo prefers larger pieces that combine incised geometric designs with clay relief forms, such as the feared *onca* or jaguar, the respected *jacare* or alligator, or the *sapo* or frog, a symbol of rain and fertility. He also produces a smaller container in the shape of a person or a *cariatide* that was used to hold ancestors' ashes.

126. Raimundo Cardosa, *Tanga* (1982).

Raimundo occasionally makes the unusual *tanga,* a small, gently curved triangle shape that was worn by Marajo women as a cover for the pubic area [*fig. 126*]. The *tanga* is related to the pre-Columbian word *babel,* or apron, and little pre-Columbian figurines have been unearthed showing the females wearing these personal *tangas,* which probably replaced feather and fiber skirts during ceremonial occasions.

This revival of Amazon Indian pottery makes representations of an ancient culture available not only to the tribal peoples of whose heritage they are a part, but to people abroad and in urbanized Brazil. This flourishing revival of an old form can help to promote respect and admiration for the indigenous people who are now trying to preserve their cultures from annihilation.

The Persistent Lace Makers

Brazil

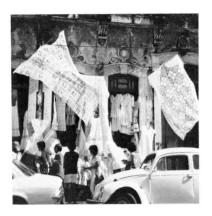

127. Lace displayed in Salvador, Bahia, Brazil (1984).

Lace is virtually impossible to avoid in the city of Salvador, Bahia, in northeastern Brazil. There, lace vendors flamboyantly display their delicate wares—from intimate lace bikinis to enormous lace tablecloths that wave above shops like flags in the breeze. These diverse and intricate laces are created by hand by local women [*fig. 127*].

An open form of lace cloth made by twisting and knotting threads was produced in pre-Columbian Peru, but the formal art of lacemaking, dependent upon parchment patterns, pins, pillows and bobbins was developed by the nuns in Italian convents during the Middle Ages, later to become a cottage industry of peasant women throughout Europe. Lace making was introduced to Brazil by the Portuguese in the 1600s. The creation of homemade lace virtually ceased in Europe after World War I, but the Brazilian lace makers and their art have persisted.

For many of the residents of Salvador, lace is not just an extra trimming but plays a profound role in the special garments worn by Candomblé celebrants. Candomblé is the extremely traditional form of ancient West African religion, preserving in Bahia even those elements that have vanished in contemporary Africa. In Salvador there are 4000 *terreiros,* or centers of observances, and hundreds of candles can be seen burning on the beaches every night. Emphasizing the union of natural forces and psychic energies, this psychospiritual heritage survived three centuries of slavery and persecution by superficially incorporating Catholic saints. One can see in the streets of Salvador proud priestesses and initiates wearing distinctive long white skirts and blouses composed of layers of lace. During special holidays the streets become impassible with processions of celebrants, all wearing white lace garments and white turbans. And, of course, these are worn by dancers during regular rites. The costume, according to one priestess, is only the appearance—it has no meaning outside the ceremonials. However, it gives power to the incarnation of the god or goddess in the trance dancer. The gods are incomplete without their attributes, the formal details of dress must be respected.

In recent years there has been a worldwide revival of interest in fashions which incorporate lace. Since northeast Brazil has become renowned for its lace production, buyers from all over the world take advantage of the modest prices of the handmade lace made here by women from Ilha de Mare and Salvador. There are four different styles of lace: the *renda de bilro,* lace produced with bobbins; *rendendebo,* made on an embroidery hoop; *renda inglesa,* English lace; and *file,* lace formed by knotting threads, something like macrame.

Unlike most of the other shops in the city that advertise as *Artesanato de Rendas* (Artisans of Lace), that of Ester Almeida Dos Santos's family display only the lace that they make. Other merchants purchase their lace primarily from Ilha de Mare, though there are several, nearby small towns with active lace makers.

Ester generally greets visitors with a piece of lace in her hand, an activity by which she has supported her family for over twenty-seven years. For many generations the women of Ester's family, including her mother, grandmothers, and cousins, have, as prominent lace makers in the city of Inhombupe, been the family breadwinners. Eleven years ago she established her own combined home and shop in Salvador. Most of the year she and her family concentrate for long hours each day on several projects at a time. Months are required to complete large items such as eight-foot-long tablecloths made by stitching together smaller pieces. The cost of an elaborate circular or rectangular tablecloth can range from $80 to $120.

Ester recalls that by the time she was six, she had begun to learn the extremely complex process of *renda de bilro*. "You should start to learn lace making with bobbins as a young girl, because it is very rare that an older woman can master this form of lace making." It is a pleasure to watch her hands rapidly creating *rendendebo* lace. She begins on a piece of solid-color cotton cloth mounted on a circular embroidery hoop [*fig. 128*]. After embroidering a rectangular, patterned design, she cuts little rectangular window-like openings with sharp scissors. The outer edge of the cloth is also shaped, embroidered, and cut so that it repeats the interior geometric structure [*fig. 129*].

The less rigid, curved forms of her *renda inglesa* [*fig. 130*], combine the use of a thin white ribbon, used to outline the basic design, with an intricate lace thread. First the design is planned on parchment paper, pinned to a firm cushion; then

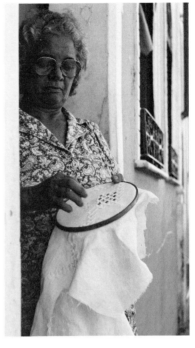

128. Ester Almeida dos Santos, *rendendebo* technique (1984).

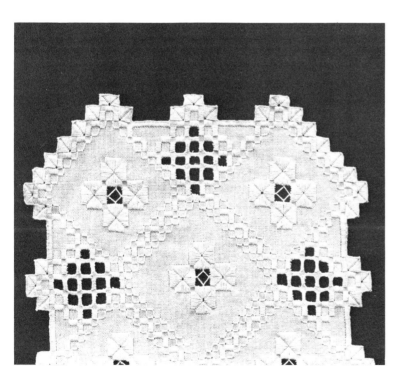

129. Ester Almeida dos Santos, *rendendebo* lace (detail) (1984).

pins placed along the pattern define the design, holding ribbon and threads in place, as the lace is formed by an embroidery needle.

Now sixty-two, Ester has not only supported her four children through sales of lace, but has seen them through the university. In the competitive field of lace making, she has achieved a reputation for quality. She told me that she continuously develops new designs for her lace, and that they are often copied by others. "But if I am creating only new, one-of-a-kind patterns, I can't survive." She must depend on producing a substantial volume for her income. "Americans," she says, "prefer to buy lace garments like skirts, dresses, blouses, and bikinis, whereas Europeans tend to purchase tablecloths and items for the home."

130. Ester Almeida dos Santos, *renda Inglesa* lace (1984).

At Ilha de Mare, which is about an hour's boat ride across the bay from Salvador, one can see groups of women sitting outside their small stucco homes which are arrayed in neat rows above the sandy bank. They are creating *renda de bilro* [*fig. 131*]. This kind of lace is developed with pins that outline the design and hold threads suspended from as many as forty-eight wooden bobbins shaped to fit the hand [*fig. 132*]. A constant throwing of thread and switching to different bobbins is done with such agility and speed it seems almost an innate skill. Although it is difficult for a casual onlooker to under-

131. *Renda de bilro* lace from Ilhe de Mare (1984).

stand completely, let alone follow the swift pace, the results are admirable. This work seems extraordinarily complicated; nevertheless, the women casually exchange news and keep an eye on playing children as they work [*fig. 133*].

Renda de bilro lace is usually in the form of repeated floral patterns interspersed with geometric designs. Visual diversity is created through the use of single threads which contrast with more solidly filled or accented areas, such as flower petal or small rectangle shapes. The nonsymmetrical balance between the arrangement of the floral motif, in which the negative areas or see-through shapes are as important as the threaded parts of the design, also contributes to an overall rhythmic vitality.

The outer form of *renda de bilro* lace is made with a heavy cotton thread and can be circular, oval, or rectangular. Each individual piece can serve as a place mat or a decorative furniture covering, or it can be stitched together with other pieces to create a larger cloth. White is the dominant color, although some women experiment with bright red, yellow, or blue. Long narrow rows of border lace for trimming skirts or dresses, collars, cuffs, vests, and other garments are also made at Ilha de Mare.

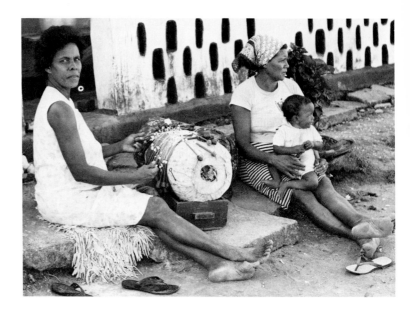

133. Lace makers, Ilhe de Mare (1984).

132. Bobbins for lacemaking, Ilhe de Mare (1984).

Wholesale buyers commission particular items, and individual shopkeepers come to Ilha de Mare from Salvador to purchase lace. These island women have little opportunity for direct sales. In fact, when occasional visitors come, these artisans ask only around five dollars for a small lace piece that can take at least four days of work to complete.

At Ilha de Mare mothers and daughters still create lace as they have for many generations. By contrast, in the urban center of Salvador, lace makers' children go to college and on to other careers. However, as long as lacework remains profitable and, even more important, essential to Candomblé ceremonial observances, Brazil's lace makers will persist.

It is ironic that lace fashions which were once the exclusive domain of the church, monarchy, and the wealthy aristocracy of Europe should have been so democratized in Latin America. Now, whenever I see or touch lace, I am reminded of the sun-bronzed faces of Ilha de Mare's mothers and daughters and of the independent, spirited Ester Almeida Dos Santos from Salvador, Bahia.

Approximately 30 percent of Salvador, Bahia's population are of pure African descent, while many others are an ethnic mixture of African, Indian and European. Salvador's museums feature elaborate collections of colonial arts, folk art, and sophisticated contemporary work, reflecting the diversity of this region's history and culture. There are also commercial art galleries that cater to the conservative taste of local Brazilians who, I am told by artists there, prefer traditional landscape and figurative paintings. But I was looking for something else.

I first encountered the folk arts of Salvador as I walked along the narrow cobblestone streets, with wood-carved masks and other figures displayed in the doorways of artisans' shops. These expressive images embody traditional myths and symbols of Salvador's Afro-Brazilian residents, and they are popular adornments to people's homes. Some contemporary pieces still evoke a bitter historic past, like the ceramic figures of a master flogging a slave [*fig. 134*].

If the many self-taught folk artists of Bahia use overtly Afro-Brazilian themes in wood carvings, pottery, and paintings, there are also professional artists who integrate international modernist influences with their national heritage. I came across one of them as the Museu de Arte de Bahia where I chanced on a one-woman exhibit of Maria Adair's paintings and drawings. Delighted by their technical mastery and sensuality, I was interested in learning more about this artist and her work. The museum's assistant director, Luiza Marquez, obligingly arranged our meeting, and she suggested other women artists I might want to meet and interview.

Four Artists of the Northeast
Brazil

134. Folk artist unknown, master and slave ceramic, Salvador, Bahia, Brazil (1984).

MARIA ADAIR

Maria Adair [*fig. 135*] says, "I admire life in its natural state of expansion, characterized by mutation: origin, growth, development.... I am a constant spectator of the logical fulfillment of nature and the world's slow evolution. My subject is life."

Adair was born in 1938 and grew up in the small town of Itaracu in northeastern Brazil. At fifteen, she wanted to study art, but when her family urged a traditional course she became a teacher. She taught a very few years, then married and lived in Itaracu with her husband and their five children. Eighteen years later, in 1972, with dramatic changes in her life, she entered the Universidad Federal de Bahia in Salvador, where by 1976 she had obtained her B.A. degree and begun painting.

In 1981 Adair came to the United States on a Fulbright fellowship, at first to study English in Pittsburgh, and then to work for her M.A. in Art at Iowa State University. She told me she had her real beginning in Pittsburgh where, for the first time, people really began to look at her work, like it, and buy it. And she loved the strange landscapes she found in the United States—from Pittsburgh's rivers to the cornfields of Iowa.

Images inspired by the unselfconscious growth of natural organic forms are central to all of her work, whether she paints on paper, canvas, fabric, nightclub walls, or salad bowls. *Constellation* [*fig. 136*], a delightful conceptual piece utilizing salad bowls, grew out of her experimentation with white circular egg forms that she cut in half to explore thematic possibilities. The finished bowls, painted in gay colors, were suspended from the ceiling by thin nylon thread in angular sequences and varying heights. She recalls with a laugh how her Iowa professor resisted this idea until he saw the finished work. A great success, the piece won acclaim for its originality and vision.

Rhythmic, flowing forms are perfectly realized in Adair's series of sensual torso paintings, in which single bodies or interlocking couples explore a kind of fluid cosmic sexuality, a transmutation of beings.

Macho-Femea (Male Female) [*fig. 137*] and *Um Rio de Emoçoes (A River of Emotions)* [*fig. 138*] are two series of twelve huge works, some of them over ten feet long.

A woman of immense energy and expansive personality with a keen sense of humor, Adair has an output so prodigious that only a year after returning to Salvador from the United States, she had three simultaneous exhibits: at the Museu de Arte de Bahia, the Berro d'Agua Bar & Restaurante, and at the Art Boulevard Gallery. She says half in jest: "I wanted three shows at once so people who normally don't go to either museums, or bars, or galleries, could see my work in whichever place they do go to." But, she told me, her work is not really popular in Brazil, where people prefer the more established figurative,

135. Maria Adair, Salvador, Bahia, Brazil (1984).

136. Maria Adair, *Constellation* (1982). Oil on wood bowl.

138. Maria Adair, *A River of Emotions* (1984). Oil on paper.

landscape, or folk artists. She says she would love to go again to the United States where there is a greater sense of innovative excitement.

She has recently completed two murals—one commissioned by the Brazilian Institute of Forest Development, the other for the entryway of Entrails, a bar in Salvador's beachfront district.

Inspired by planets, stars, ocean currents, shells, plants and seeds, Maria Adair's curved lines and eternal spirals echo the timeless forms and movements of the universe. "I never paint the flower as a flower," she says, "but as a symbol of life—as an extension of the vital life cycle."

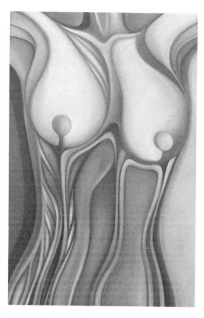

137. Maria Adair, *Male-Female* (1984). Oil on canvas.

Maria Almeida

Fabric artist Maria Almeida paints the lush tropical flowers of Brazil [*fig. 139*]. Whether a silk screen image of a single flower on paper or many blossoms on batik yardage, each image gives the impression of freshness and light. Her palette is intense and with extreme contrasts of warm and cool tones her flowers vibrate on the retina even after one has closed one's eyes.

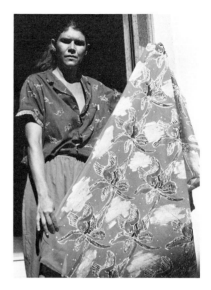

139. Maria Almeida with her fabric print (1984).

Fiber is Almeida's preferred medium, although she feels it has not been easy to introduce it: "In Brazil, it is considered a lowly craft, and people only want to buy it to make a dress. Fiber art is not appreciated in Brazil. No one knows about it, as it is not a subject that is taught in school."

Early encouragement to be an artist came from her grandfather, a musician, and her father, a writer. Born in Salvador, Bahia, in 1948, Almeida earned a B.A. degree at the Escola de Belas Artes, and then for three years taught school. She told me her education and experiences outside Brazil were vital to her development. For two years, from 1973 to 1975, she attended Adams State College, Alamosa, Colorado, where she earned her M.A. and then she travelled in Mexico and South America. Since 1980 she has been teaching full time at the Escola de Belas Artes.

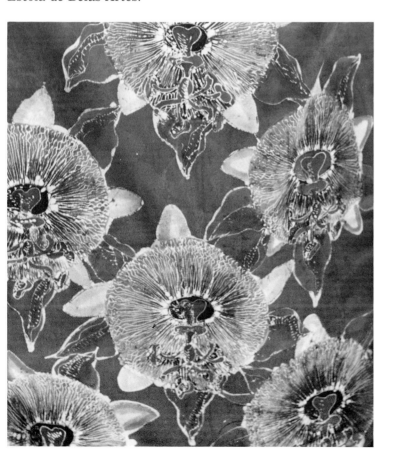

140. Maria Almeida, *Passion Flower* (1984).

Maria's apartment is arranged to accommodate her own working needs as well as those of her husband who is a photographer. Her best studio time is evenings when her young daughter is sleeping and she can work undisturbed. She tells me of disadvantages in working in Salvador: its provincialism and a scarcity of supplies for batik work.

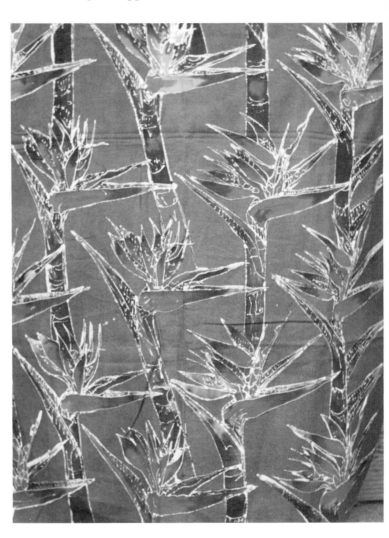

141. Maria Almeida, *Bird of Para-dise* (1984). Silk screen on fabric.

Almeida first draws the image on white fabric with hot wax with the tjanting, a batik tool. She draws freehand; therefore, no two flowers are exactly alike. The final fabric image receives many varied dye baths, the hot wax used as a stopout for each individual color. She feels that because she has chosen the flower as her subject, her work is "a struggle to create something that is not common."

That she has achieved her objective is evident in the invitation given her by the Museu de Arte de Bahia to present a one-woman exhibition of her fabulous fabrics and silk screen prints, including *Passion Flower* [*fig. 140*] and *Bird of Paradise* [*fig. 141*].

YEDAMARIA

The critical acclaim that Yedamaria [*fig. 142*] received for her first exhibit of prints was overwhelming. The Brazilian writer, Jorge Amado wrote, "Yedamaria is an artist who deserves admiration and respect. Her work, spanning many years, has been characterized by the seriousness with which it has been done, by the absence of noisy, fawning flattery, by constant study and by a limitless dedication to her *raison de vivre:* art."

Born in Bahia in 1934, an only child, Yedamaria recalls that her mother who loved music and drawing encouraged her creative pursuits. By the time she was twenty, Yedamaria had won degrees in art and education from the Escola de Belas Artes and begun to teach art, first in the secondary schools, and then at the University. Married, and the mother of one daughter, she was never tempted to give up: "I always kept up my own work. People would say to me, 'Why are you letting yourself get so tired?' and I would say, 'No, I feel good. My work is most important in my life and for my family. My work supports us and my family supports me.'"

Many of the themes of Yedamaria's 1967 oil paintings are based on the boats and harbor of Salvador. She has also produced many portraits, but from 1968 to 1972, she focused on Afro religious traditions.

A dramatic change in Yedamaria's life came in 1977 when, at forty-four, she received a scholarship to study art in the United States. Yedamaria recalled with pleasure her experiences in the United States. Her fellow students were always helpful. "They were surprised that I was a university teacher, and that I came to the United States to work on my M.F.A.... Any place black people can have problems," she told me, "but I had an amazing experience there. While in the United States, my mother had to have her leg amputated. I had no money to pay the doctor, but he said, 'Give me one of your etchings for payment of the bills.' I cried because this doctor was white and considered my people and my work on the same level as his own. That was wonderful."

"In the United States," Yedamaria observed, "black people have united, but in Brazil it is very difficult for blacks to get a good position." She does not know of any other black woman in Brazil who is a professional artist. There are not many black professionals in the university system, and no black students in her classes.

At the University of Illinois she studied mainly printmaking where she learned a variety of new graphic techniques, including color printing. It was here, too, that she moved from spiritual subjects to a subject very down to earth—food.

"The preparation and eating of traditional foods are very important to my people," she told me. Many of the delicious, savory foods of Salvador are prepared and sold on the streets

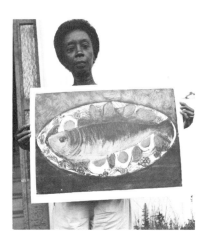

142. Yedamaria with *Fish on a Platter* (1983). Lithograph.

143. *Yedamaria, Wood Tray* (1983).
Lithograph.

by Afro-Brazilian women who sit at street corners with their little portable cookstoves and tables. In Yedamaria's 1983 lithograph, *Wood Tray,* the little bowls that contain hot peppery sauces and spicy brown shrimp cakes are all clustered together on the tray [*fig. 143*]. In *Blue Porcelain* [*plate 13*], a similar still life, flower motifs are repeated on the blue and white porcelain bowls beside a long silvery fish. Two tomatoes and a lemon in the foreground are also cut open like star-shaped flowers. In both of these lithographs the litho pencil is used to shade each object and create solid, three-dimensional forms.

The red and yellow colors of the fruit in her etching, *Lunch* [*fig. 144*], appear particularly warm and lush; everything in this composition, fruit, pottery and flowers, has a joyous rhythm. To get intense color mixtures, she uses three separate etching plates, each one inked with red, yellow or blue—then they are printed one over another to get a range of secondary colors and to give a richness of etching textures to the final print.

In the etching, *Bandega (Tray)* [*fig. 145*], Yedamaria uses solemn black, grey, and white for the shining silver Brazilian espresso coffee pots. The elongated reflection of these pots on

144. Yedamaria, *Lunch* (1983). Etching.

the tray's surface contrasts with their elegantly curved handles and angular spouts. She is working on a series of black and white etchings almost as a response to a challenge, because "some people say my images are only good in color. No problem; now, if I want, I can do them in black and white also with good results."

In order to etch or work on lithographic stones, Yedamaria commutes to São Paulo to Yamazo's graphic workshop studio. Her paper, materials, and printing equipment are free; in turn, she gives the graphic workshop half of her production to sell.

Even with exhibits, sales and critical acclaim, Yedamaria still teaches full time at the Escola de Belas Artes. With a new house with better studio space, she plans to buy her own etching press so she can produce her own prints and continue developing a wide range of Afro-Brazilian spiritual themes.

145. Yedamaria, *Bandega* (1983). Etching.

SONIA CASTRO

Graphic artist Sonia Castro has worked in theater, film, and print media at the Architecture Institute of the University of São Paulo and at the Federal University of Bahia, where she has taught. She began her professional studies as a painter, but later switched to graphic arts media. Her woodblock prints, etchings and lithographs are now in many national and international collections, such as those of the Museu de Arte Moderna de Bahia, Museu de Arte Moderna de São Paulo and the Museum of Modern Art of New York.

Born in Salvador in 1934, her family encouraged her academic and art studies. "Since my childhood I always had paper and crayons in my hand," Castro says. After graduating from the Federal University of Bahia and the Escola Bela Arte in design and painting , she began to study printmaking. From 1972 to 1973 Castro studied at the University of Birmingham in England and traveled through Europe. She designed Brazil's 1983 poster for the International Year of the Woman.

Now on the faculty of the university, she says that "During the last decade there have been more women students, and women have no problem in teaching on the university level. However, there are no words to describe the deplorable conditions of the universities... teachers and students have been on a protest strike for two months. The present government seems to have no interest in funding education or culture, and most buildings are somewhat abandoned or in ruins."

She told me why she makes prints. "Paintings get lost in time, whereas graphics which allow for multiple originals that can sell at a lower cost is nearer to Brazilian reality, as it gives more people an opportunity to buy and live with original art. This is important as artists must live from selling their art.

"My work is very social, although I paint or make prints to agree with myself. As I develop an image, I think only of the composition, the pattern and the visual effect, and my social commentary must be integrated within the aesthetic concept." A 1975 series of three stark black and white woodblock prints [*figs. 146, 147, 148*] she calls "a protest without words" makes a powerful statement through facial expressions alone and by the organization of forms in space. The theme is people waiting, whether to see "a movie, to buy something in a store or to wait for conditions in society to change.

"I need to live close to the city. My preoccupation is with people; all should have an opportunity for self-expression. The old concept that artists are selected by God is good for the artist, but is not reality. Everyone, including workers and older people, should have an opportunity to appreciate as well as to create art, not just a small privileged group of artists."

One of Castro's frequent subjects is Woman, rendered as a "ghost image." "We are full of inner ghosts which can be expelled only through our work," she says. Rather than discarding the woodblock when she is through printing a limited

146. Sonia Castro, *People Waiting #1* (1980). Woodblock.

147. Sonia Castro, *People Waiting #2* (1980). Woodblock.

148. Sonia Castro, *People Waiting #3* (1980). Woodblock.

edition of seven to twenty-five, she will occasionally paint on top of the woodblock, or add photo collage, fabric and other textures. *Ghost Image* [*plate 11*], is a haunting example. Interspersed between the cut linear outline of the female figure are other faces that peer out at us. Fluid linear rhythms unite figures painted in subdued purple, brown, and green-blue. A mood of ominous mystery prevails.

The art critic, Mario Barata, describes the emotional impact of Castro's "...figures that are almost profiles. I'd rather call them shadows, for they are real and not phantasmal. Their emotional power is intimately related to an alive white. It's not deep, but makes effective its predominance as light and environment, a surface-world of beauty and sensation."

Sonia Castro perceptively sums up what many people throughout the world are now thinking: "We are at a crossroads. We are in danger of a nuclear war, and the development of all humanity will either continue or disintegrate. All artists at this time need to stop and think more about politics and the conditions of the world. Sometimes I lose hope about the pathway of humanity, but to be an artist is the best work in the world."

Impressions

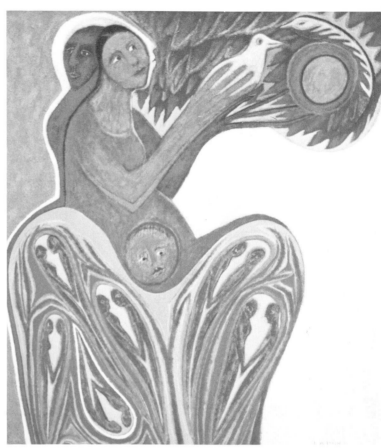

Homage to the Mothers of the Disappeared

Nurtured by the rich ethnic diversity and multifaceted ancient and contemporary cultures of the Latin American peoples, I have responded with paintings and prints that express my impressions of their reality.

While the sketchbook is always with me as I travel, for recording my immediate impressions based upon a more realistic interpretation of daily events, the paintings and prints germinate slowly and evolve in my home studio after each journey. They represent my symbolic summation of selected experiences that can also involve each culture's ancient myths, as well as contemporary traditions and current political reality.

Along with the selected examples of my work, I have added a few verbal clues to place the images within a specific cultural context. I hope that my visual impressions of Latin America will reach out beyond the confines of national boundaries to reveal that, in spite of our cultural differences, human survival is dependent on our ability to connect with one another through understanding and compassion.

Betty LaDuke

Pachamama and the Magic Leaves

BIBLIOGRAPHY

Adelson, Laurie and Tract, Arthur. *Aymara Weavings.* Smithsonian Institution: Exhibition Service, 1983.

Anderson, Marilyn. "Guatemala Civil War and the Crafts," *Crafts International,* January, 1983.

Anderson, Marilyn. "Guatemala Traditional Weaving in a Life and Death Struggle," *Crafts International,* October, 1983.

Burns, E. Bradford. *A History of Brazil.* New York: Columbia University Press, 1970.

Cultural Survival Quarterly, Vol. 6:3, Vol. 6:4, Cambridge, Mass., 1933.

Doyon, Claude-Auguste. *The World of Haitian Painting.* Smithsonian Institution: Traveling Exhibition Service, 1974.

Galeano, Eduardo. *Open Veins of Latin America.* New York: Monthly Review Press, 1973.

Graburn, Nelson. *Ethnic and Tourist Arts.* Berkeley: University of California Press, 1976.

Grenada Bulletin 1. New York: Grenada Resource Center, 1980.

Gual, Enrique. *Fanny Rabel.* Mexico, D.F.: Anahuac Cia, S.A., 1968.

Kelsey, Vera. *Four Keys to Guatemala.* New York: Funk and Wagnalls Company, 1943.

Keeler, E. Clyde. *Land of the Moon Children.* Athens: University of Georgia Press, 1956.

Lyle, Moore and Navaretta. *Women Artists of the World.* New York: Midmarch Associates, 1984.

LaFeber, Walter. *Inevitable Revolution.* New York: W. W. Norton and Company, 1983.

Lernoux, Penry. *Cry of the People.* Garden City, New York: Doubleday and Company, 1980.

Litto, Gertrude. *South American Folk Pottery.* New York: Watson-Guptill, 1976.

Osborne, Lilly de Jongh. *Indian Crafts of Guatemala and El Salvador.* Norman: University of Oklahoma Press, 1965.

Parker, Ann and Neal, Cwon. *Molas, Folk Art of the Cunas.* Barre, Mass.: Barre Publishing, 1977.

Randall, Margaret. *Doris Tijerino, Inside the Nicaraguan Revolution.* Vancouver, B.C.: New Star Books, 1978.

Randall, Margaret. *Women in Cuba.* New York: Smyrna Press, 1981.

Rigol, Jorge. *Museo Nacional de Cuba—Pintura.* Havana, Cuba: Editorial Letras Cubanas, 1978.

Rodman, Selden. *Popular Artists of Brazil.* Old Greenwich, Conn.: Devin-Adair Company, 1977.

Scharper, Philip and Sally. *The Gospel in Art by the Peasants of Solentiname.* Maryknoll, New York: Orbis Books, 1984.

Walker, Sheila. "The Bahamian Carnival," in *Black Arts: An International Quarterly.* Vol. 5 No. 4. Los Angeles, 1984.

ART EXHIBIT

Latin America: Women as Artists and Artisans, by Betty LaDuke. Circulated by Exhibit Touring Services of Washington State, 1986–1988. For further information contact Sid White, Director of Exhibit Touring Services, Evergreen State College, Olympia, Washington 98505.

CITY LIGHTS PUBLICATIONS

Angulo de, Jaime. INDIANS IN OVERALLS
Angulo de, J. and G. de Angulo. JAIME IN TAOS
Artaud, Antonin. ARTAUD ANTHOLOGY
Bataille, Georges. EROTISM: Death and Sensuality
Bataille, Georges. STORY OF THE EYE
Bataille, Georges. THE TEARS OF EROS
Baudelaire, Charles. INTIMATE JOURNALS
Baudelaire, Charles. TWENTY PROSE POEMS
Bowles, Paul. A HUNDRED CAMELS IN THE COURTYARD
Brecht, Stefan. POEMS
Bukowski, Charles. THE MOST BEAUTIFUL WOMAN IN TOWN
Bukowski, Charles. NOTES OF A DIRTY OLD MAN
Bukowski, Charles. TALES OF ORDINARY MADNESS
Burroughs, William S. THE BURROUGHS FILE
Burroughs, William S. THE YAGE LETTERS
Cardenal, Ernesto. FROM NICARAGUA WITH LOVE
Cassady, Neal. THE FIRST THIRD
Choukri, Mohamed. FOR BREAD ALONE
CITY LIGHTS REVIEW #1: Politics and Poetry issue
CITY LIGHTS REVIEW #2: Forum AIDS and the Arts issue
CITY LIGHTS REVIEW #3: Media and Propaganda issue
CITY LIGHTS REVIEW #4: Literature / Politics / Ecology
Cocteau, Jean. THE WHITE BOOK (LE LIVRE BLANC)
Codrescu, Andrei, ed. EXQUISITE CORPSE READER
Cornford, Adam. ANIMATIONS
Corso, Gregory. GASOLINE
David-Neel, Alexandra. SECRET ORAL TEACHINGS IN TIBETIAN
 BUDDHIST SECTS
Deleuze, Gilles. SPINOZA: PRACTICAL PHILOSOPHY
Dick, Leslie. WITHOUT FALLING
di Prima, Diane. PIECES OF A SONG: Selected Poems
Doolittle, Hilda (H.D.). NOTES ON THOUGHT & VISION
Ducornet, Rikki. ENTERING FIRE
Duras, Marguerite. DURAS BY DURAS
Eidus, Janice. VITO LOVES GERALDINE
Eberhardt, Isabelle. THE OBLIVION SEEKERS
Ferlinghetti, Lawrence. LEAVES OF LIFE
Ferlinghetti, Lawrence. PICTURES OF THE GONE WORLD
Ferlinghetti, Lawrence. SEVEN DAYS IN NICARAGUA LIBRE
Finley, Karen. SHOCK TREATMENT
Ford, Charles Henri. OUT OF THE LABYRINTH: Selected Poems
Franzen, Cola, transl. POEMS OF ARAB ANDALUSIA
García Lorca, Federico. ODE TO WALT WHITMAN & OTHER POEMS
García Lorca, Federico. POEM OF THE DEEP SONG
Gascoyne, David. A SHORT SURVEY OF SURREALISM
Ginsberg, Allen. THE FALL OF AMERICA
Ginsberg, Allen. HOWL & OTHER POEMS
Ginsberg, Allen. KADDISH & OTHER POEMS
Ginsberg, Allen. MIND BREATHS
Ginsberg, Allen. PLANET NEWS
Ginsberg, Allen. PLUTONIAN ODE

Ginsberg, Allen. REALITY SANDWICHES
Goethe, J. W. von. TALES FOR TRANSFORMATION
Hayton-Keeva, Sally, ed. VALIANT WOMEN IN WAR AND EXILE
Herron, Don. THE LITERARY WORLD OF SAN FRANCISCO
Higman, Perry, transl. LOVE POEMS FROM SPAIN AND SPANISH AMERICA
Jaffe, Harold. EROS: ANTI-EROS
Kerouac, Jack. BOOK OF DREAMS
Kerouac, Jack. SCATTERED POEMS
Lacarrière, Jacques. THE GNOSTICS
La Duke, Betty. COMPANERAS: Women, Art & Social Change in Latine America
La Loca, ADVENTURES ON THE ISLE OF ADOLESCENCE
Lamantia, Philip. MEADOWLARK WEST
Lamantia, Philip. BECOMING VISIBLE
Laughlin, James. THE MASTER OF THOSE WHO KNOW
Laughlin, James. SELECTED POEMS: 1935-1985
Le Brun, Annie. SADE: On the Brink of the Abyss
Lowry, Malcolm. SELECTED POEMS
Marcelin, Philippe-Thoby. THE BEAST OF THE HAITIAN HILLS
Masereel, Frans. PASSIONATE JOURNEY
Mrabet, Mohammed. THE BOY WHO SET THE FIRE
Mrabet, Mohammed. THE LEMON
Mrabet, Mohammed. LOVE WITH A FEW HAIRS
Mrabet, Mohammed. M'HASHISH
Murguía, A. & B. Paschke, eds. VOLCAN: Poems from Central America
O'Hara, Frank. LUNCH POEMS
Paschke, B. & D. Volpendesta, eds. CLAMOR OF INNOCENCE
Pasolini, Pier Paolo. ROMAN POEMS
Pessoa, Fernando. ALWAYS ASTONISHED
Poe, Edgar Allan. THE UNKNOWN POE
Porta, Antonio. KISSES FROM ANOTHER DREAM
Prévert, Jacques. PAROLES
Purdy, James. IN A SHALLOW GRAVE
Purdy, James. GARMENTS THE LIVING WEAR
Rey-Rosa, Rodrigo. THE BEGGAR'S KNIFE
Rigaud, Milo. SECRETS OF VOODOO
Saadawi El, Nawal. MEMOIRS OF A WOMAN DOCTOR
Sawyer-Lauçanno, Christopher, transl. THE DESTRUCTION OF THE JAGUAR
Sclauzero, Mariarosa. MARLENE
Serge, Victor. RESISTANCE
Shepard, Sam. MOTEL CHRONICLES
Shepard, Sam. FOOL FOR LOVE & THE SAD LAMENT OF PECOS BILL
Smith, Michael. IT A COME
Snyder, Gary. THE OLD WAYS
Solnit, Rebecca. SECRET EXHIBITION: Six California Artists of the Cold War Era
Solomon, Carl. MISHAPS PERHAPS
Solomon, Carl. MORE MISHAPS
Tutuola, Amos. FEATHER WOMAN OF THE JUNGLE
Tutuola, Amos. SIMBI & THE SATYR OF THE DARK JUNGLE
Valaoritis, Nanos. MY AFTERLIFE GUARANTEED
Wilson, Colin. POETRY AND MYSTICISM